Fairfield Porter

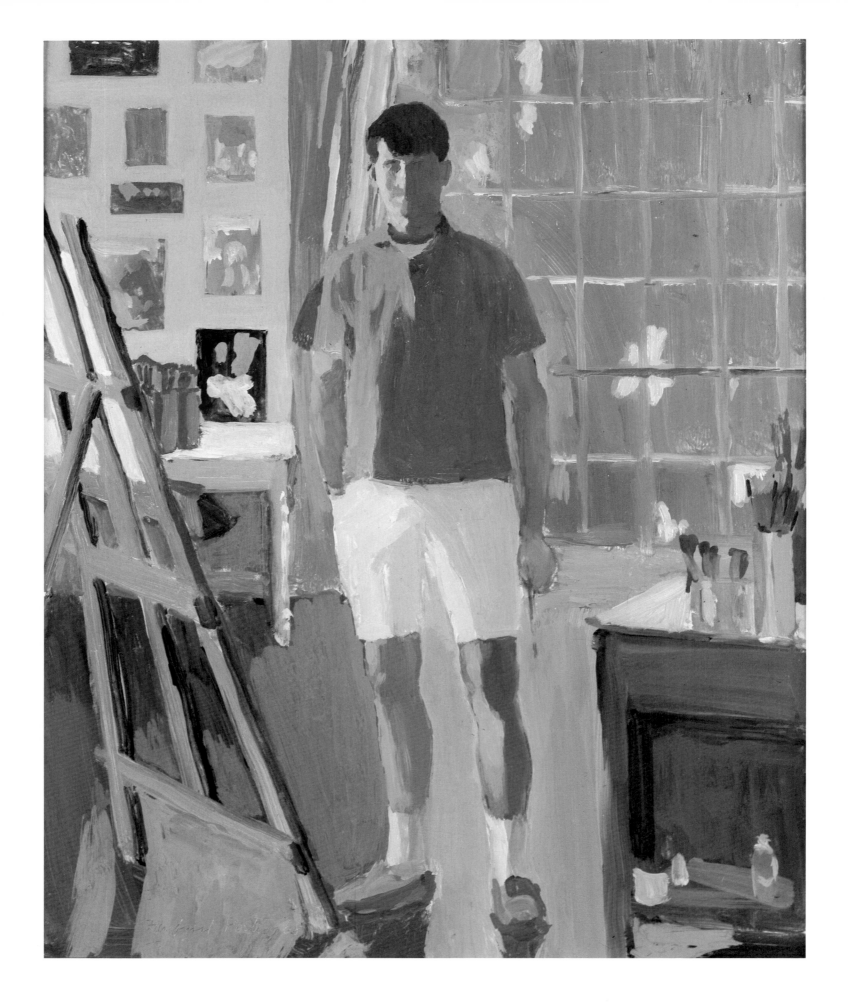

Fairfield Porter

(1907-1975)

Realist Painter in an Age of Abstraction

Essays by John Ashbery and Kenworth Moffett

Contributions by John Bernard Myers, Paul Cummings, Prescott D. Schutz,

Rackstraw Downes, and Louise Hamlin

Museum of Fine Arts Boston, Massachusetts

Acknowledgments

My greatest debt in organizing this show is to Prescott
D. Schutz of Hirschl & Adler Galleries in New York.
His good counsel and knowledge of Fairfield Porter's
work were enormous assets, and in most ways he was
the co-curator of this exhibition. Deborah Emerson,
my assistant, has done a large part of the work on the
show, and I am also indebted to G. Peabody Gardner III
for his work on the tour. I thank John Bernard Myers,
Tibor de Nagy, John Ashbery, Rackstraw Downes,
Jane Wilson, John Gruen, Paul Cummings, Philip
Ferrato, Alan Fink, and Barnet Rubenstein, all of
whom gave of their time to help me with the catalogue
and organization. I am grateful to Armistead Leigh for
providing me with some of Porter's letters. Mr. Leigh
is currently collecting Porter's correspondence for
publication. I want especially to thank Anne Porter,
who supplied letters and other information.

Mention should be made here of the art critic Hilton
Kramer, who has insisted on Porter's importance for
many years, and also the Cleveland Museum of Art,
which organized the first Porter retrospective in 1966
and shows a continuing commitment by hosting this
exhibition.

— Kenworth Moffett, *Curator of 20th-Century Art*

Exhibition Itinerary

Museum of Fine Arts, Boston
January 12 – March 13, 1983

Greenville County Museum of Art, Greenville,
South Carolina
April 13 – June 19, 1983

Cleveland Museum of Art, Cleveland
November 9 – December 31, 1983

Museum of Art, Carnegie Institute, Pittsburgh
February 18 – April 22, 1984

Whitney Museum of American Art, New York
May 31 – July 22, 1984

Copyright 1982
by the Museum of Fine Arts, Boston, Massachusetts
Library of Congress catalogue card no. 82-62231
ISBN 0-87846-231-7 (paper) 0-87846-211-2 (cloth)
Printed in U.S.A. by Acme Printing Co., Medford, Massachusetts
Designed by Carl Zahn
Cover illustration: **116.** *The Harbor — Great Spruce Head*, 1974
Frontispiece: **73.** *Self-Portrait in the Studio*, 1968

Preface

This monograph and corresponding retrospective exhibition are projects the Museum of Fine Arts, Boston, has wished to do for several years. A major building program and an exhibition schedule to which we had previously committed ourselves have required the patience and fortitude of all those most closely involved in this retrospective. Perhaps these delays were a blessing in disguise, for there has not been a time in the past half century when the interest and activity in realist painting has been higher among artists, critics, curators, dealers, and collectors. It also seems very appropriate that a retrospective of Porter's work follows that of Thomas Eakins here at the MFA. Not only is Porter's art a continuation of the tradition of American realism begun by Eakins a century earlier, but his life paralleled that of Eakins in many ways as well.

On behalf of the trustees and staff of the MFA, I wish to express our pleasure in having the opportunity to organize this exhibition and to send it on a national tour. There are many people who contributed their time, expertise, and energy to this project. In particular, however, I wish to extend our gratitude to the artist's widow, Mrs. Anne Porter, and the Hirschl and Adler Galleries, which manages the estate of the artist. As always, of course, without the trust and generosity of the many private and institutional lenders this project would not have been possible. Finally, I wish to thank our sister museums who share our vision and will be hosting the exhibition in their respective cities around the country. Our partners are The Greenville County Museum, Greenville, South Carolina; The Cleveland Museum of Art; Museum of Art, The Carnegie Institute, Pittsburgh; The Whitney Museum of American Art, New York.

— Jan Fontein, *Director, Museum of Fine Arts, Boston*

Contents

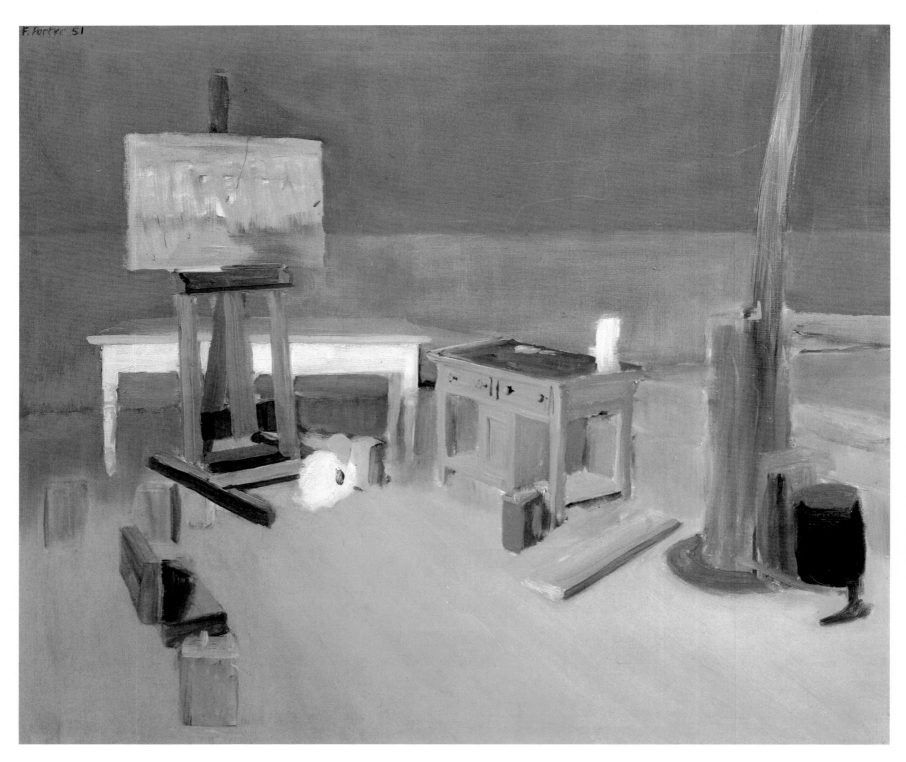

7. *Studio Interior*, 1951

* *

Respect for Things as They are

by John Ashbery

In his introduction to Fairfield Porter's posthumous collection of art criticism, *Art in Its Own Terms*, Rackstraw Downes quotes a remark Fairfield Porter made during what must have been one of the more Byzantine discussions at the Artists' Club on Eighth Street, around 1952. The members were arguing about whether or not it was vain to sign your paintings. With the flustered lucidity of Alice in the courtroom, Porter sliced this particular Gordian knot once and for all: "If you are vain it is vain to sign your pictures and vain not to sign them. If you are not vain it is not vain to sign them and not vain not to sign them."[1] We do not know the reaction of his colleagues; quite possibly this *mise au net* fell on the same deaf ears that ignored the urgent but plain and unpalatable truths that Porter voiced again and again in his writings on art, at a time of particularly hysterical factionalism. No one likes to be reminded of the obvious, when half-truths are so much richer and more provocative; thus it was Porter's fate both as critic and as painter to play the role of a Molière gadfly, an Alceste or a Clitandre in a society of stentorian *précieuses ridicules*. And to a certain extent, his reputation as an eccentric remains, though it stemmed from a single-minded determination to speak the truth. Handsome is as handsome does; actions speak louder than words: who, in the course of the Artists Club's tumultuous sessions, could pause to listen to such drivel?

I hadn't known this statement of Porter's before reading Downes's preface, but somehow it caused all my memories of the man I knew well for more than twenty years (without, alas, pausing very often to look or listen well) to fall into place. Porter was, of course, only the latest of a series of brilliant know-nothings who at intervals have embodied the American genius, from Emerson and Thoreau to Whitman and Dickinson down to Wallace Stevens and Marianne Moore. Her title "In Distrust of Merits" could stand for all of them and her preference for winter over summer reminds me of Porter's saying in a letter to a friend: ". . . November after the leaves have fallen may be one of the best times of year on Long Island. That is, I like the way the trees don't block the light any more."[2] And I realized after such a long acquaintanceship that his paintings, which most people like but have difficulty talking about (Are they modern enough? Too French? Too pleasant? Hasn't this been done before?), are part of the intellectual fabric that underlay his opinions, his conversation, his poetry, his way of being. They are intellectual in the classic American tradition of the writers mentioned above because they have no ideas in them, that is, no ideas that can be separated from the rest. They *are* idea, or consciousness, or light, or whatever. Ideas surround them, but do not and cannot extrude themselves into the being of the art, just as the wilderness surrounds Stevens's jar in Tennessee: an artifact, yet paradoxically more natural than the "slovenly" wilderness that approaches it, and from which it takes "dominion."[3] Porter wrote of de Kooning: "His meaning is not that the paintings have

1. Fairfield Porter, *Art In Its Own Terms*, ed. Rackstraw Downes (New York: Taplinger, 1979), pp. 21-22.

2. Fairfield Porter, "Letters to Claire and Robert White," *Parenthèse*, no. 4 (1975), p. 209.

3. Wallace Stevens, *The Collected Poems of Wallace Stevens* (New York: Alfred Knopf, 1955), "The Anecdote of the Jar."

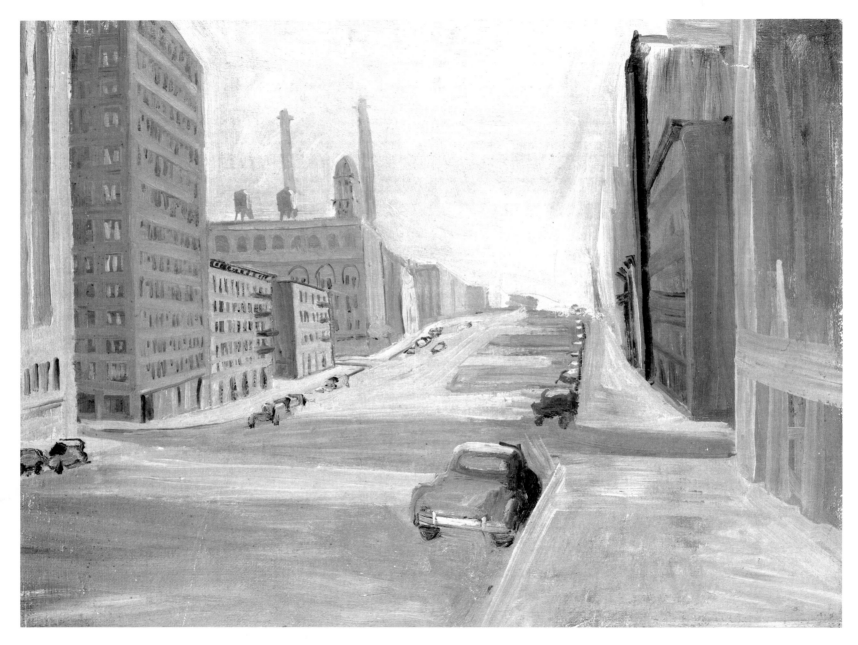

2. *First Avenue*, ca. 1945

Meaning. . . .The vacuum they leave behind them is a vacuum in accomplishment, in significance, and in genuineness,"[4] and, as so often, the critic's words apply to his own art as well.

Porter had a horror of "art as sociology," of the artist who "treats art as though it were raw material for a factory that produces a commodity called understanding."[5] For art and that commodity are one, and art that illustrates an idea, however remotely or tangentially, has forfeited its claim to be considered art by introducing a fatal divisiveness into what can only be whole. "I can't be distracted from paying the closest possible attention to what I am doing by evaluating it ahead of time," he wrote in a letter to the critic Claire Nicolas White. "What one pays attention to is what is real (I mean reality calls for one's attention) and reality is everything. It is not only the best part. It is not an essence. Everything includes the pigment as much as the canvas as much as the subject."[6] Although Porter's work is in some ways the product of an idea — the idea that ideas have no place in art, or at any rate that they have no separate life of their own in art, no autonomy that might siphon off part of the "reality" of the ensemble — it is in accord, appearances to the contrary, with the seemingly more "advanced" work of the contemporaries he admired: de Kooning, Johns, Lichtenstein, Brice Marden, the music of Cage and Feldman — artists whose work at first seems worlds apart from the backyards and breakfast tables that were Porter's subjects but were only a part of "everything."

4. Porter, *Art In Its Own Terms*, p. 38.
5. Ibid., p. 42.
6. *Parenthèse*, no. 4, p. 212.

Even today there are admirers of Porter's painting who are bemused by his apparently wayward tastes in art, just as there are those who can't understand how Cage and Virgil Thomson can see anything in each other's music, forgetting how art submerges categories. "You can only buck generalities by attention to fact," Porter continued. "So aesthetics is what connects one to matters of fact. It is anti-ideal, it is materialistic. It implies no approval, but *respect* for things as they are." This last point seems hardest to digest for artists who believe that art is "raw material for a factory that produces a commodity called understanding." Thus, politically "concerned" artists continue to make pictures that illustrate the horrors of war, of man's inhumanity to man; feminist artists produce art in which woman is exalted, and imagine that they have accomplished a useful act; and no doubt there are a number of spectators who find it helpful to be reminded that there is room for improvement in the existing order of things. Yet beyond the narrow confines of the "subject" (only one of a number of equally important elements in the work of art, as Porter points out) the secret business of art gets done according to mysterious rules of its own. In this larger context ideology simply doesn't function as it is supposed to, when indeed it isn't directly threatening the work of art by trivializing it, and trivializing as well the importance of the ideas it seeks to dramatize.

For Porter, the enemy was "idealism," which was very close to something called "technology." As a citizen he was preoccupied — almost obsessed, in fact — with questions of ecology and politics, and politics of a most peculiar sort; he had been something of a Marxist in the thirties

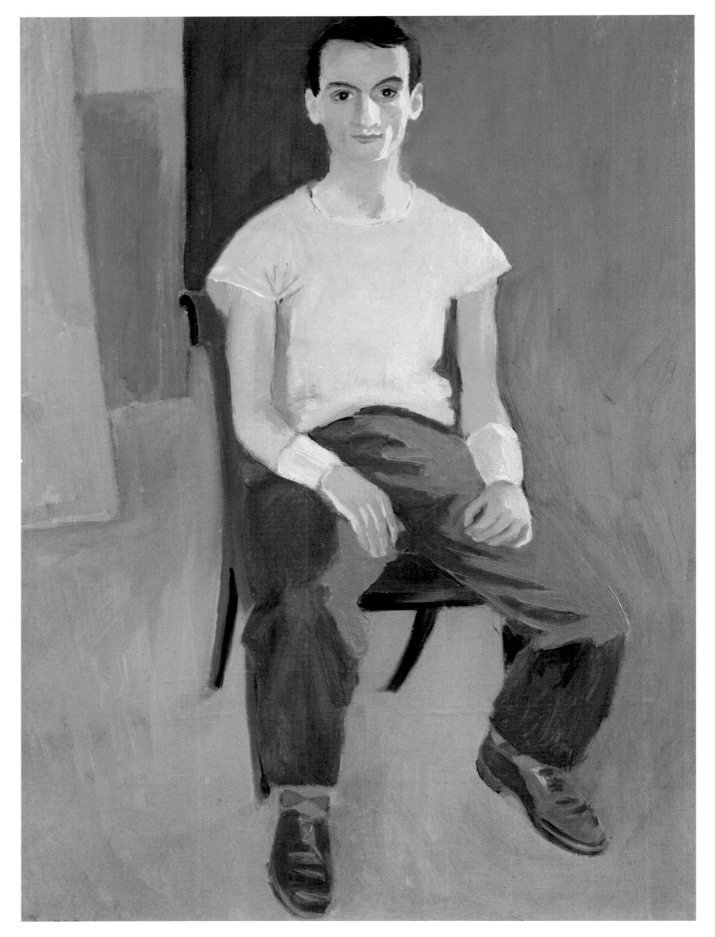

6. *Larry Rivers*, 1951

but in later life his political pronouncements could veer from far left to extreme right without any apparent transition. And in conversation he could become almost violent on subjects like pesticides or fluoridation, to the extent that his friends would sometimes stifle giggles or groans, though one almost always had to agree with him, and the years since his death in 1975 have proved him even righter than he knew. Nevertheless, this passionately idealistic man felt threatened by idealism. "Technology . . . has only to do with evaluation and usefulness. Technology is what threatens all life on this planet. It is idealism put into practice."[7] If I understand him, it is not idealism that is dangerous, far from it, but idealism perverted and destroyed by being made "useful." Its uselessness is something holy, just like Porter's pictures, barren of messages and swept clean, in many cases, by the clean bare light of November, no longer masked by the romantic foliage.

In an earlier letter to Mrs. White, Porter complained about several sentences in an article she had written about him and submitted to him before publication. One was: "Since he does not like the white, misty summer light of the Hamptons he goes to an island in Maine in the summer." This nettled him because: "the fact is, we go to Maine in the summer because I have since I was six. It is my home more than any other place, and I belong there. . . . The white misty light would never be a reason for my doing anything."[8] And no doubt the suggestion that he would travel to paint in a place where the light was better was inconceivable, since the whole point was to put down what was there wherever he happened to be, not with approval but with respect. "Subject matter must be normal in the sense that it does not appear sought after so much as simply happening to one," writes Louis Finkelstein in what is the best discussion I have ever seen of the technique and content of Porter's paintings.[9] (Finkelstein is not giving a prescription here, merely characterizing Porter's "naturalness.")

Another sentence that Porter objected to in Mrs. White's article was this: "The Porters are quiet, intense and rather fey and seem to live on an enchanted planet of their own."[10] He did not give a reason for his objection, and perhaps none was necessary. But Mrs. White could not really be blamed for her assessment; there was an element of truth in it despite the discomfort it caused Porter. His house in Southampton was an enchanting place: large and gracious but always a little messy and charmingly dilapidated. One of the bathrooms was more than that, while in an upstairs hall the wallpaper hung in festoons and no one seemed to mind. The children were strangely beautiful, wide-eyed, and withdrawn, and they spoke like adults. There were idiosyncratically chosen paintings by de Kooning, Larry Rivers, and Leon Hartl (a little-known artist whom Porter admired enormously) on the walls, along with Audubon and *Ukiyo-e* prints and a strange Turner drawing; there was a lovely smell in the house, made up of good cooking, oil paint, books, and fresh air from the sea. All of which

7. Ibid.
8. Ibid., p. 210.

9. Louis Finkelstein, "The Naturalness of Fairfield Porter," *Arts*, May 1976, p. 102.
10. *Parenthèse*, no. 4, p. 210.

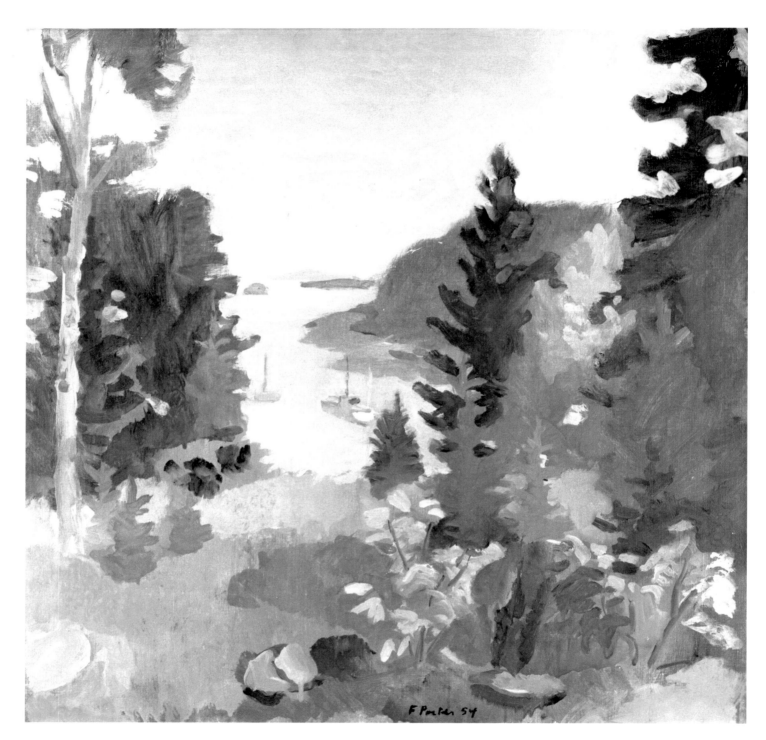

12. *The Harbor through the Trees*, 1954

might lead one to see Porter as a homespun Intimist, a view that his trumpeted admiration for Vuillard would seem to reinforce. (Characteristically, he tended to prefer the late woolly Vuillards to the early ones everyone likes.) And it may be that Porter's unexplained objection to Mrs. White's "enchanted planet" line was prompted by his unwillingness to have his work thus construed and thereby diminished.

For, the more one looks at them, the less the paintings seem celebrations of atmosphere and moments but, rather, strong, contentious, and thorny. He painted his surroundings as they looked, and they happened to look cozy. But the coziness is deceiving. It reverberates in time the way the fumbled parlor-piano tunes in the "Alcotts" section of Ives's "Concord" Sonata do. The local color is transparent and porous, letting the dark light of space show through. The painting has the vehemence of abstraction, though it speaks another language.

In the same letter Porter quoted from memory a line of Wittgenstein that he felt central to his own view of aesthetics: "Every sentence is in order as it is." And he went on astonishingly to elaborate: "Order seems to come from searching for disorder, and awkwardness from searching for harmony or likeness, or the following of a system. The truest order is what you already find there, or that will be given if you don't try for it. When you arrange, you fail."[11] I think it is in the light of statements like these that we must now look at Porter's painting, prepared to find the order that is already there, not the one that should be but the one that is.

11. Ibid., p. 211.

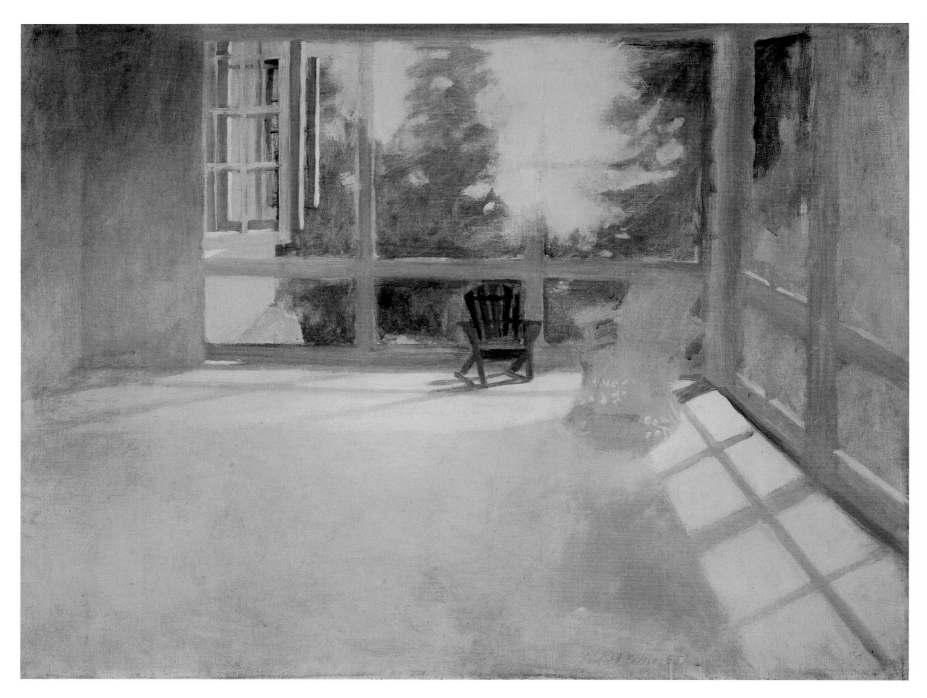

13. *Armchair on Porch,* 1955

The Art of Fairfield Porter

by Kenworth Moffett

The fourth of five children born to James and Ruth Porter, Fairfield Porter grew up in Winnetka, Illinois, just north of Chicago. His father's mother had owned the land that later became Chicago's Loop area, and the Porters were very comfortable; Fairfield never had to work, except for some years in the forties. His chief artistic influence as a child was his father, who was an architect and had built the Greek Revival house they lived in. His father loved Italian pictures and placed photographs of famous paintings and buildings and plaster casts of Greek sculpture all over the house. There were trips abroad to the great picture galleries of Europe, and Fairfield developed personal opinions about art and the history of painting by the time he was fourteen.

His next big artistic influence was Harvard University, where he studied art history. Later he singled out Arthur Pope and his course, "Drawing and Painting and Principles of Design," as having been especially important to him. Also he absorbed, as did everyone at Harvard in those years, the aesthetics of Bernard Berenson. It was at Harvard (or possibly even before) that Porter decided to become a painter. Upon graduating, he enrolled at the Art Students League in New York. Just how excited Porter had gotten about art comes across in this description of him by a contemporary, Frank Rogers:[1]

I must tell you of a most enjoyable meeting this afternoon. As I was coming home from class I bumped into a fellow I had known at the League in New York. As a matter of fact he was on his way to look me up having seen my name at the American Express office.

1. This letter was written by the painter Frank Rogers to his fiancée, Katherine Darlington House, in the early 1930s.

His name is Porter his first name I've forgotten. I had not known him well and yet I had. We had been in the same class and admired each other's intelligence. We liked Boardman Robinson but not John Sloan as teachers. But that was about all. I once went to dinner with him and thought him a bit too intellectual tending toward mannerism. But the point to all this meeting is not the meeting itself but the enjoyment it gave both of us. He is quite an unusual fellow and I must tell you about him. He met me at 5:15 and had to catch a train for Florence, Italy at 6:45. For several weeks he had not talked much with anyone — much art, that is. Neither had I and we were both bubbling over, so that into that hour and a half we tried to cram every new idea we had, both of us talking a mile a minute and interrupting one another. What enthusiasm! We yelled. We laughed. We argued. He told me about glazing [a process of painting]. El Greco and Rubens used it he says. We talked about painters and both agreed that Rubens was wonderful, having thought him rotten in America. It was all pell-mell, fast and furious. I loved it. And I like this fellow Porter very much. I think I'll write him. You would like him immensely. He's so enthusiastic — the only person I know of as enthusiastic on art as I am — the *only one*. He's rushing all over Europe the same as I want to do. He's already been to Italy once. He's nuts about Rubens and Giotto and Piero della Francesca — same as I am. We have more in common than anyone else I know of. He said to me, "I think I'm just beginning to understand Rembrandt." Me too. This crazy nut is going from Italy to Russia (he's trying to learn Russian now). He wants to see what Communism is like. Ha! I know of no greater joy than such a meeting where both people are just bursting with repressed ambition, pride, love, and enthusiasm. During our conversation he turned to me and said: "Don't you sometimes feel that you're just *wonderful*?" "I do" he said. "Sometimes I'm so wonderful I want to tell

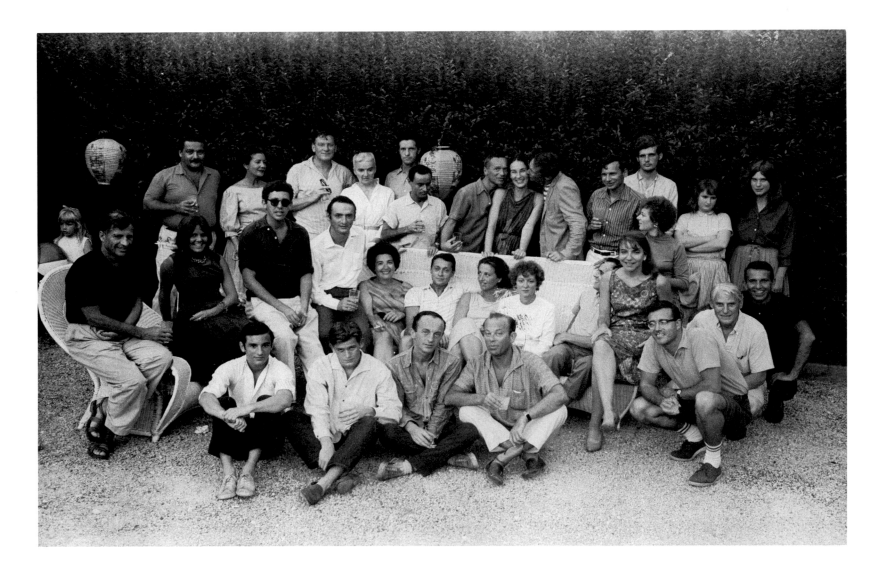

Back row, left to right: Lisa de Kooning (little blond child), Frank Perry, Eleanor Perry, John Myers, Anne Porter, Fairfield Porter, Angelo Torricini, Arthur Gold, Jane Wilson, Kenward Elmslie; Paul Brach, Jerry Porter (behind Brach), Nancy Ward, Katharine Porter, friend of Jerry Porter. *Second row, left to right:* Joe Hazan, Clarice Rivers, Kenneth Koch, Larry Rivers. Seated on couch: Miriam Shapiro (Brach), Robert Fizdale, Jane Freilicher, Joan Ward, John Kacere, Sylvia Maizell. *Kneeling on the right, back to front:* Alvin Novak, Bill de Kooning, Jim Tommaney. *Front row:* Stephen Rivers, William Berkson, Frank O'Hara, Herbert Machiz. *Photographed at Water Mill, New York, 1961, by John Gruen.*

everyone; they ought to know it. It isn't right that they don't." How many times haven't I felt that? I've written you about it! Ha! But the way he asked me in all seriousness. Life is really fine, Katherine. I wonder what this fellow, Porter, will ever do. He's got lots of talent and appreciation of the old masters. If he doesn't let his intellectual side carry him away, he'll be good.

This confidence and intense love of art doesn't appear in Porter's paintings for almost thirty years. Born in 1907, he was of the same generation as many of the Abstract Expressionists, most of whom he knew. He decided to become a painter early and painted throughout his whole life. But he didn't become noteworthy until the 1950s, and he did major work only during the last twenty years of his life. The fact that Porter's art blossomed very late is even more surprising when he tells us that he discovered how he wanted to paint as early as 1938, the year he saw an exhibition of Vuillard and Bonnard at the Art Institute of Chicago: "When I was young I thought I ought to paint like the Old Masters but it didn't interest me very much. Then in Chicago I saw a big show of Vuillard and Bonnard. The Vuillards first seemed so helplessly obvious. I thought to do it! And I did."[2]

Porter's discovery of modern art was the discovery of Impressionism. He believed that "the Impressionist revolution implied that the value of art was intrinsic, and that this was much more of a revolution than anything that succeeded it," as

Rackstraw Downes has put it. To Porter, the formal essence of Impressionism was that paint and color, rather than contour and shading, give substance; "the contour was unimportant relative to the interior light, substance and weight it contains." In other words, for Porter, Impressionism was the painterly way of re-creating the presence of reality. Porter thought that Vuillard represented the "natural" fulfillment of Impressionism. He liked Vuillard better than Bonnard, and he liked Vuillard's later work more than his early "Nabis" period pictures. This is the same taste that was so taken by two pictures of Velázquez shown at the Metropolitan Museum right after the war. Velázquez became his favorite painter.

I was beginning to be interested in what you can do with paint — what is the quality of paint, what is its nature, and I admired the liquid surface of Velázquez. And what might be called his understatement, though I don't like that word. The impersonality — I don't know what word to use. He leaves things alone. It isn't that he copies Nature; he doesn't impose himself upon it. He is open to it rather than wanting to twist it. Let the paint dictate to you. There's more there than there is in willful manipulation. I used to like Dostoevsky very, very, very much. Now I prefer Tolstoy for the same reason. He is like Velázquez for me.

Porter saw in both Vuillard and Velázquez sovereign artistic personalities who were able to balance their love of the medium and their love of visual reality in such a way as to respect the inherent individuality of both. Here is Porter's ideal, "a strong man without egoism," as he once wrote of John Button. It explains why he liked Vuillard better than Bonnard. For Bonnard's wayward and equivocal brushing imposes itself, how-

2. Quotes from Porter come from a collection of his critical essays, *Art In Its Own Terms*, edited by Rackstraw Downes (Taplinger Press, New York, 1979), or from the interview conducted by Paul Cummings, excerpted in this catalogue.

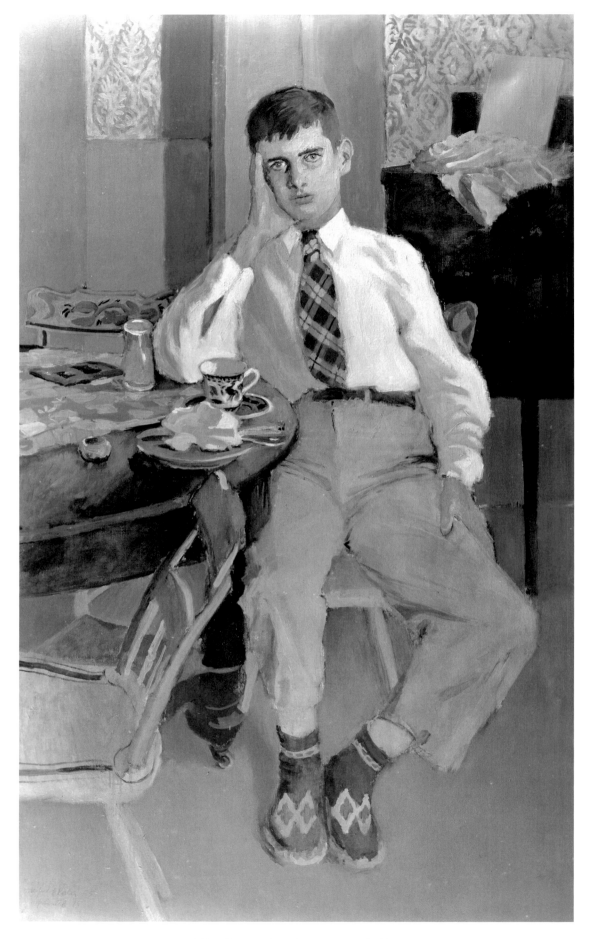

15. *Jerry*, 1955 (repainted 1975)

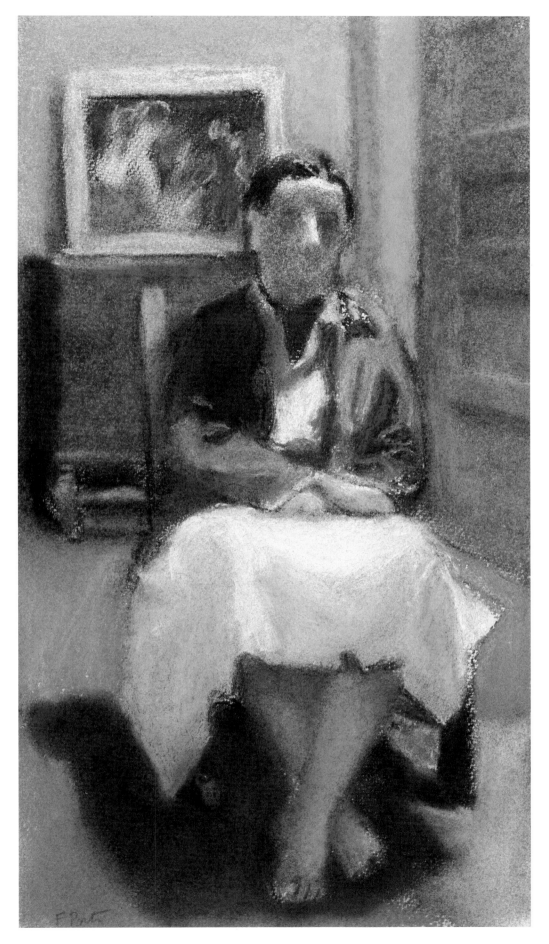

129. *Jane Freilicher*, ca. 1955

ever passively, on the structure of reality. Porter didn't like deliberate distortions, which he called "affectation," just as he didn't like bravura, which he called "performance." The post-Impressionists, and especially Cézanne, seemed to him to have imposed themselves too much on the individuality and structure of nature, and he felt their art represented a falling off from the Impressionists and Vuillard. In fact, Porter usually saw the whole period from Cézanne to World War II in negative terms. He felt it had been too "conceptual," too involved with ideas. According to Porter, it is only with Abstract Expressionism that we again have a kind of painting like Impressionism that is both empirical and respectful of its means. This was Porter's reading of modern art. He felt that it was Vuillard, not Cézanne, who had "made of Impressionism something solid and durable like the art of the museums." "Vuillard organized Impressionist discoveries about color and pigments into a coherent whole." Or Vuillard was more "coherent and orderly" than Monet. Now it can be said that more than Cézanne or Bonnard or Monet, Vuillard, especially the later Vuillard, kept to traditional perspective and drawing. He was innovative, fresh, personal, mostly in his handling of paint and in his unusual sense of color. Something like this could be said about Porter, too; he experienced what we think of as Vuillard's conservatism, a respect for the wholeness, uniqueness, and presence of the world.

That Porter was so struck by Vuillard's "firmness and wholeness" has to do, I think, with his early experiences with Old Master painting and his training at Harvard's Fogg Museum, which was then permeated by Renaissance ideals and classical aesthetics. When studying with Arthur Pope or reading Bernard Berenson's books, Porter's taste for traditional structure and pictorial decorum was probably first confirmed. An emphasis on structure and traditional composition was also part of Benton's teaching at the Art Students League. Vuillard and Velázquez showed him that the modern equivalent was to use this traditional structure to create a new visual unity that gives the emphasis to light and the physical properties of oil paint. What could be more natural? Indeed, Porter's approach is really an extension of nineteenth-century naturalism: nature and its given order are exploited for the sake of art.

Porter saw himself as discovering Vuillard's great importance and developing his approach further. Only in his last years, and only in a few pictures, did he start to become as broad and arbitrary as Matisse or Milton Avery. Never did he willfully distort or break with a perceived reality. (I'm, of course, talking about his general conception, not details and areas, which can become very abstract indeed.) What Porter wrote about Jane Freilicher can be said of himself: ". . . when she has to choose between the life of the painting and the rules of construction, she decides to let the rules go. The articulation of some of the figures is impossible and awkward, and though this is a fault, it is a smaller fault than murder." This quote shows a willingness to depart from received, traditional structure when it is necessary for aesthetic wholeness, but it also shows a great respect for this same structure.

Another reason for Porter's respect for structure is that it didn't come easily to him. Later, Porter would complain that there wasn't anyone to teach him about painting. His teachers at the Art Students League, Robinson and Benton, were

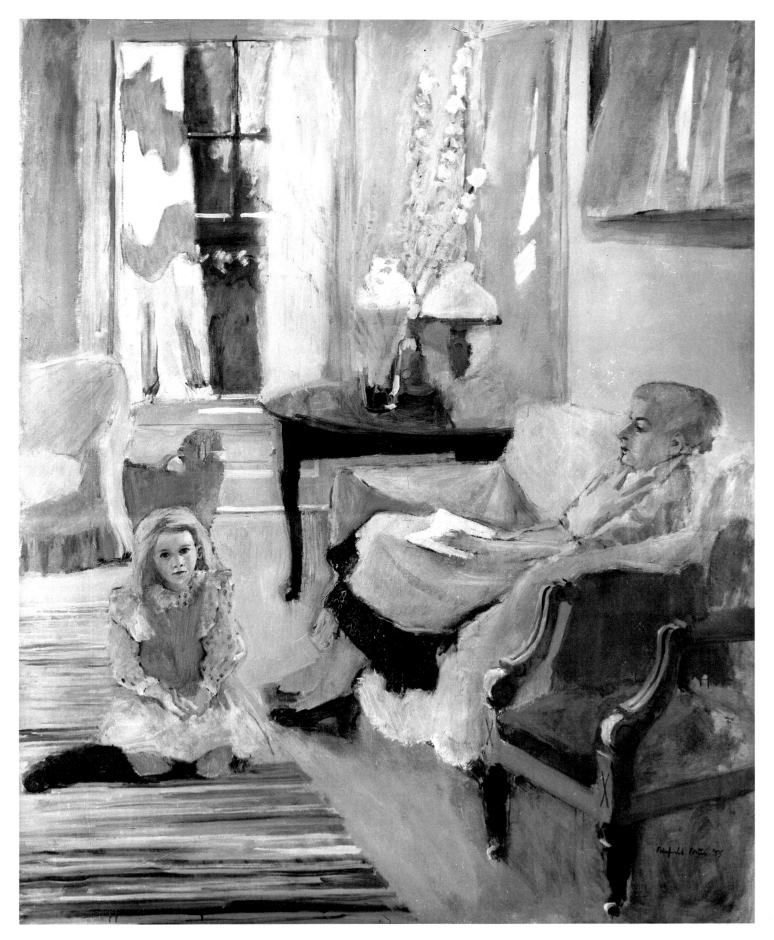

14. *Katie and Anne,* 1955

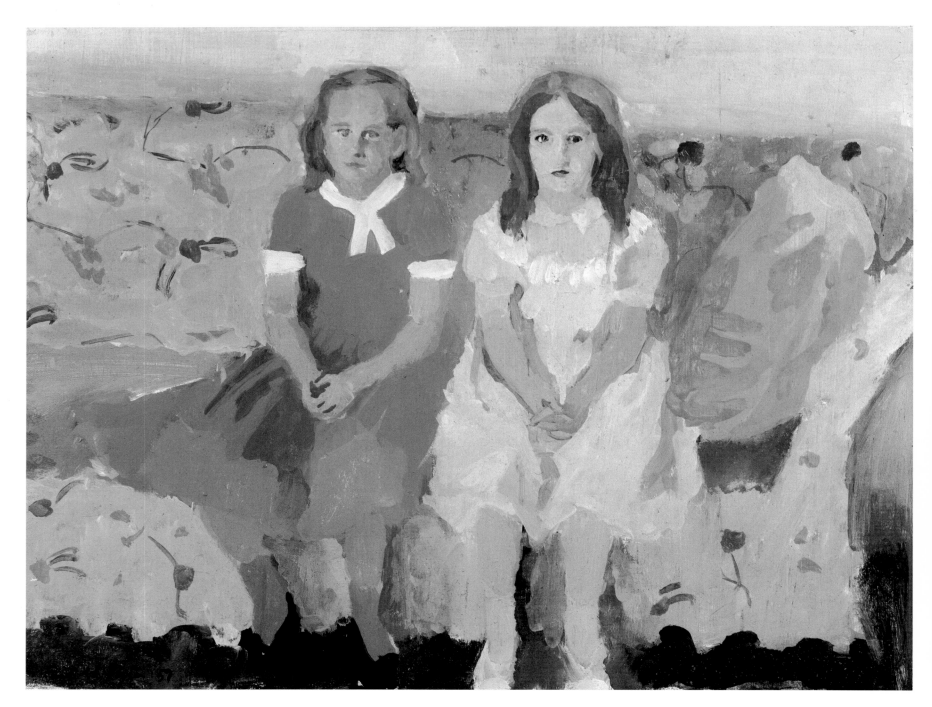

18. *Katie and Dorothy E., 1957*

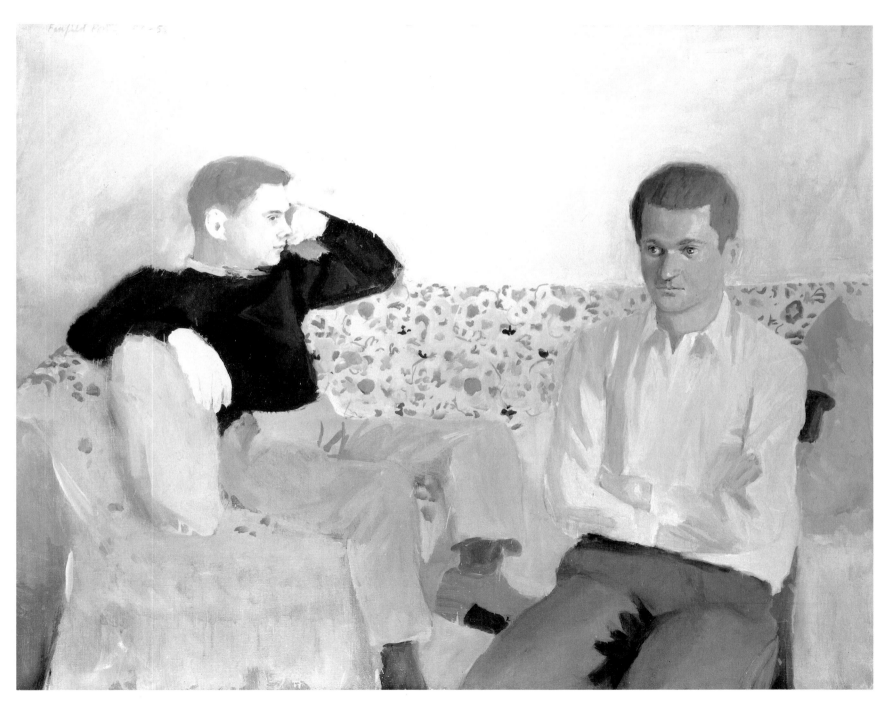

20. *Jimmy and John,* 1957-1958

both dry and graphic. Nowhere did he find a direct, sensuous, full-bodied approach to the medium of oil painting. "I don't think anyone in America knew how to paint in oils at the time." There had been beginnings by the American Impressionists, and especially by Robert Henri and John Sloan, but, as Porter never tired of pointing out, the Armory Show cut off these promising developments and diverted energies into different channels. French painterly naturalism never had an uncompromising representative in this country. Even with Homer and Sargent or the early Sloan, there is a predominance of extra-painterly, usually illustrational, concerns and a consequent lack of that balanced concentration on the medium and on nature that Porter spoke of.

Perhaps a lack of precedents and teachers (or models) helps explain the primitive character we find so often in Porter's work. There is an awkwardness, stiffness, even a woodenness most noticeable in his figures (especially from the waist down) that can give a naive flavor to a scene, often hurting the picture. Then, there is his overdiligent, even provincial sense of finish in his oils, which (if not as pronounced as in Milton Avery's case) is never wholly overcome.[3] Porter complained that he had to learn to paint from scratch, and America's lack of a developed painting culture may also help to explain why he was such a "late bloomer." He was drawn to a kind of painting that wasn't available in this country until after the war (and then in the form of

abstract art). Before the war Porter's art is tepid and dim. It looks like the work of a gifted but diffident amateur. His father, who hadn't continued as an architect, didn't provide him an example of ambition or even of an abiding interest but, still, where was that confident and passionate young man that Frank Rogers met in Italy? Here is how Porter himself explained his slow and feeble start. He wrote to the painter Arthur Giardelli in January of 1958:

I now have five children: three sons, 23, 22, and 17; and two daughters, 8 and almost 2. Their names are: John, Laurence, Jerry, Katharine and Elizabeth. John was sick from birth with a mysterious illness that was never quite understood, but seems to be a failure of development of his nervous system caused probably by an unrecognized virus infection that Anne had during pregnancy. He seems simple minded — he remains childish and can't take care of himself quite, so he lives on a farm in Vermont where his foster parents keep schizophrenics and such like [meaning Johnny] free from responsibilities. It wasn't until about seven years ago that we arrived at this solution. No psychiatrists or doctors seemed to know anything definite about him, and the result on me was that I really did nothing for about the first ten years of his life but try to somehow help him. This was a most frustrating experience, because I was trying to solve something for which there was no solution. Then after that, that is after deciding, on advice from a psychiatrist, to send him to a foster home, I began to have a career or life of my own. This started by my getting a job on *Art News*, from which followed the possibilities of exhibitions for me, and at last a recognition for me as a painter. It wasn't until after the war that I could concentrate on painting, that means paint without thinking of my supposed failure as a father in this one case.

Porter had undergone psychoanalysis in the

3. Porter's other characteristic fault is overcrafting a picture, as he tended to do, for example, when he painted a large version of a small watercolor, or when he made lithographs from previous paintings.

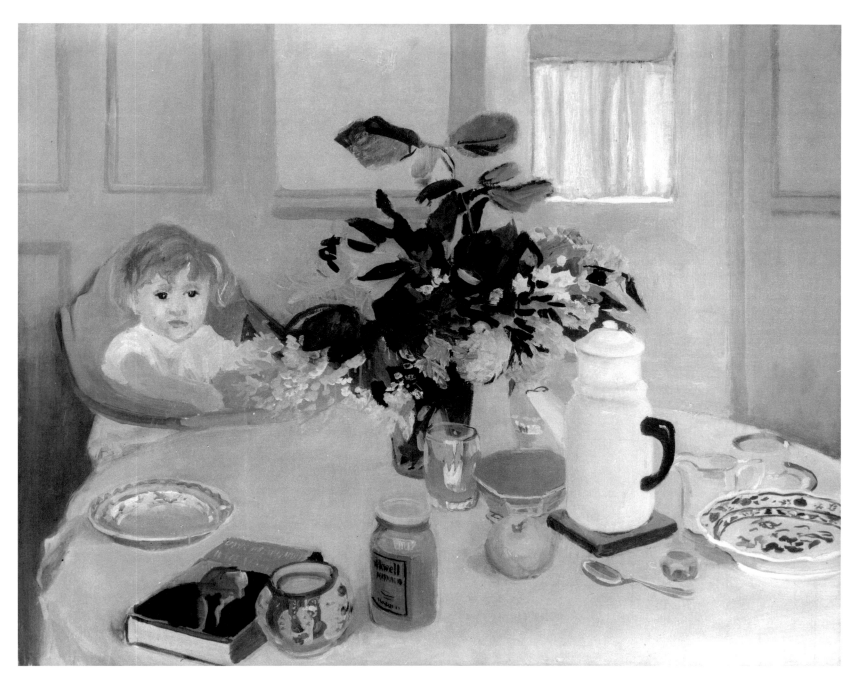

21. *Lizzie at the Table*, 1958

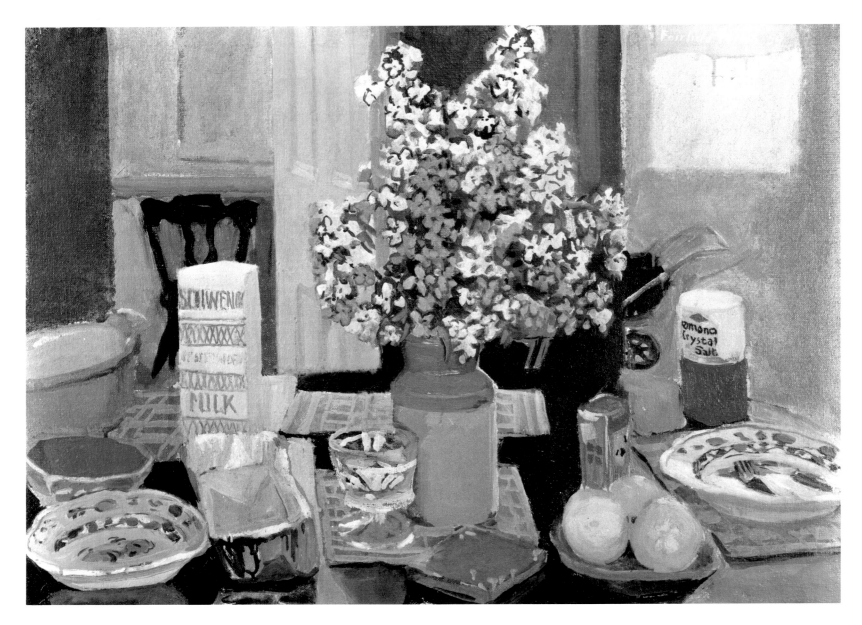

27. *Schwenk,* 1959

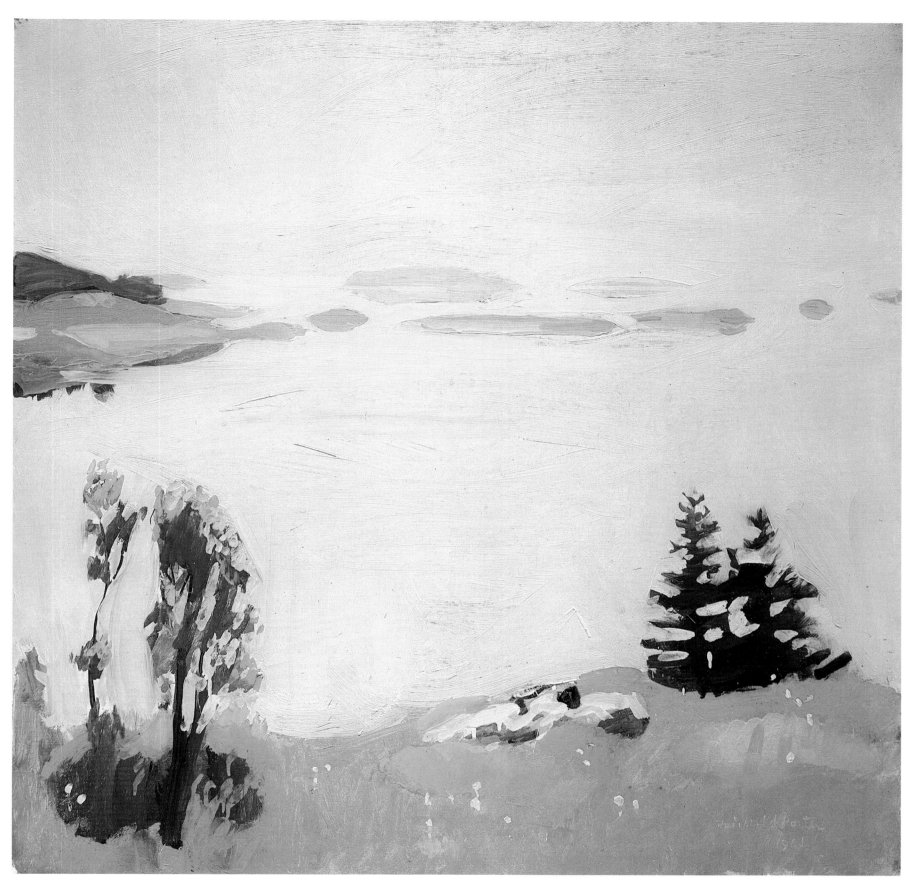

34. *Calm Morning,* 1961

middle forties and the realization he speaks of here was probably one result. He pointed to his overscrupulous conscience as having hampered him. Interestingly enough, this recalls the thesis of a book Porter wrote about Thomas Eakins some years later.[4] The tone of the book is critical and negative. According to Porter, Eakins suffered from "a rigidity that followed from fulfilling the demands of an inorganic conscience" that held him back until the very end of his life. "It required him to think that beauty must be justified. It is paid for in difficulties, it is justified in scrupulousness in conformity to nature; things must be finished, accurate. Because his father's money enabled him not to have to work for a living, he had to convince his conscience that painting was work." Porter saw Eakins's scientific preoccupations as efforts to make art into something he could justify as work. For Porter, Eakins's genuinely painterly instincts were in conflict with his conscience.

There may be more than just a little projection or identification here. In the thirties Porter was preoccupied with politics, and throughout his life he felt the need to justify the artist's profession to himself and others. He had to contend with an overactive intellect and an overactive conscience, just like Eakins. So at the very end of his life, when he was doing his most innovative work, he could still play with the idea of giving up painting to devote himself full-time to organic gardening or to the nuclear disarmament movement. Somewhere, Porter seems to have felt that painting was too selfish an occupation, and that entering into it in a wholehearted way was somehow

4. Porter's great-aunt had studied with Eakins.

self-indulgent. As if to remind himself, Porter once wrote "ideally conscience is directed toward the difficulty of achieving artistic integrity." To affirm the sensual, full-bodied painting that he loved best meant for him a struggle. This helps explain why he was so slow to react even after he was stimulated by post-war developments and a new, more sympathetic context. Only slowly, Porter let himself be carried away by art again. But once he got going, his work continued to gain in freedom, richness, flexibility, and full bodiedness. To the very end, there is an increase in riskiness, clarity, and grace.

Until he began to write for *Art News* Porter was relatively isolated, at least from other artists. His writing helped him focus himself and reviewing regularly put him in constant contact with other artists, critics, and dealers. Porter was entering the New York art world at exactly the time when the New York School, the Abstract Expressionists, were about to gain ascendancy and even world leadership. Seeking to emulate them, a new generation of artists had collected in New York, and some of them opened cooperative galleries on 10th Street. The contemporary art scene was about to take a quantum leap in size and popularity. Porter became part of this exciting, ambitious, and mostly younger crowd. Gaining visibility and meeting sympathetic artists who liked his pictures, he got into the Tibor de Nagy Gallery, one of New York's most respected avant-garde galleries.

Willem de Kooning, whom Porter had met in the 1930s, was his most important influence at this time. He was the one member of the older generation who continued to refer to the figure tradition, and he was the most accessible and available to the younger artists. The *chef d'école*

of 10th Street and a charismatic personality, de Kooning seemed to Porter the prototype of the European painter still in touch with the great traditions of Europe. Even when de Kooning's work became bombastic and grotesque in the early 1950s, miles away from the "understatement" and "naturalness" that Porter loved in Vuillard and Velázquez, de Kooning still impressed him. If Porter saw Impressionism through the eyes of the Renaissance, he saw de Kooning through the eyes of Vuillard. He couldn't understand the abstract art that was developing around him in those years, although he was much conditioned by the climate and ideas that it generated.[5] De Kooning especially influenced his ideas and helped him to be bolder. To Porter, de Kooning's pictures were an illustration of an outlook, an affirmation of "the means so as to say painting is physical and material — a reality itself." Moreover, de Kooning made "an attitude toward work the subject matter of his art." His aggressive, full-bodied assertion of the value of painting as painting helped give Porter confidence in himself.[6]

A more physical approach to the medium (or to "work") meant a larger surface and a bigger stroke. This forced Porter to see in broader masses. Another important change was the high key of his color. This, too, was characteristic of much of the abstract painting he was seeing, although Porter's soft, warm, dry, bright light owes as much to Tiepolo (whom he copied) as to any contemporary pictures. Basically, his impressionist way of working remained the same; he just scaled it up and brightened it. He seems to have gotten an added push in this from a number of the younger 10th Street painters who were working along similar lines: Alex Katz, John Button, Larry Rivers, and Jane Freilicher. Porter was confirmed and challenged by their work (and influenced them in turn).[7]

5. Porter often made the point that there is no essential difference between abstract and representational art, and that each is "real" or has "presence" in a different way. He understood the aesthetics of abstraction, but he didn't have an eye for abstract art. To go by his writings, he didn't seem to have especially liked the work of any of the Abstract Expressionists except de Kooning, and possibly Kline, two of the weakest members. He couldn't see Pollock's pictures, he didn't like the work of Mark Rothko, Clyfford Still, or Barnett Newman, and he showed no interest in the pictures of Adolph Gottlieb or Hans Hofmann.

There is a note of rivalry in Porter's relationship to Clement Greenberg, the critic who was most in touch with the best abstract art. See, for example, his rather carping attack on Greenberg's pioneering essay "American Type Painting," republished in *Art In Its Own Terms*. Porter boasted that he "always" disagreed with Greenberg in their discussions and that he believed his views on art were "just as good" as Greenberg's. He even claimed that he painted from nature to disprove one of Greenberg's assertions! All this sounds competitive and also may be the result of factionalism on Porter's part. Greenberg was disliked among the 10th Street group that had taken up Porter, mainly because he championed Pollock and downgraded de Kooning.

As an art critic, Porter is straightforward, clear, and sometimes even brilliant when talking about art in general. His opinions and ideas about the art of the past are fresh and interesting. But what he wrote remains an artist's criticism. Like so many artists, he was too preoccupied with his own work to be a very just or illuminating judicial critic. He never took being an art critic completely seriously, i.e., as seriously as he took — or came to take — being an artist.

6. De Kooning was Porter's most important influence at this time (as he himself said), but it shouldn't be overstressed. After the war, Porter also studied at the Parsons School with Jacques Maroger, the famous Louvre restorer, from whom he learned the use of a wax medium that he used thereafter. Also, he always spoke of how much he learned from a Dutch painter and connoisseur named van Hooten. He seemed to have learned a lot about painting from these two European traditionalists (albeit unorthodox ones).

7. Porter didn't like the painting of the other group that developed

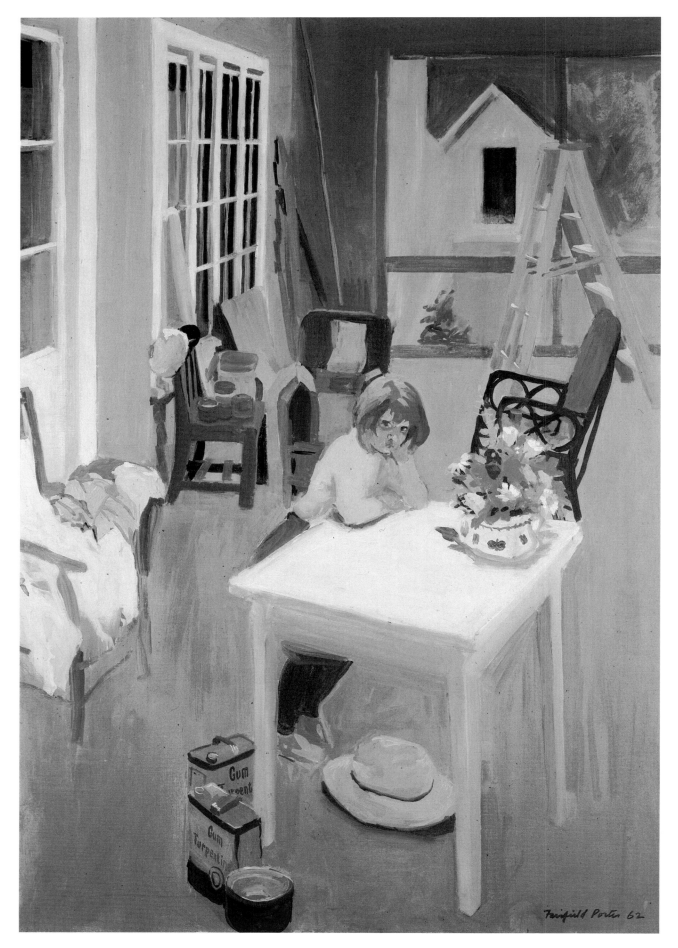

37. *Summer Studio, 1962*

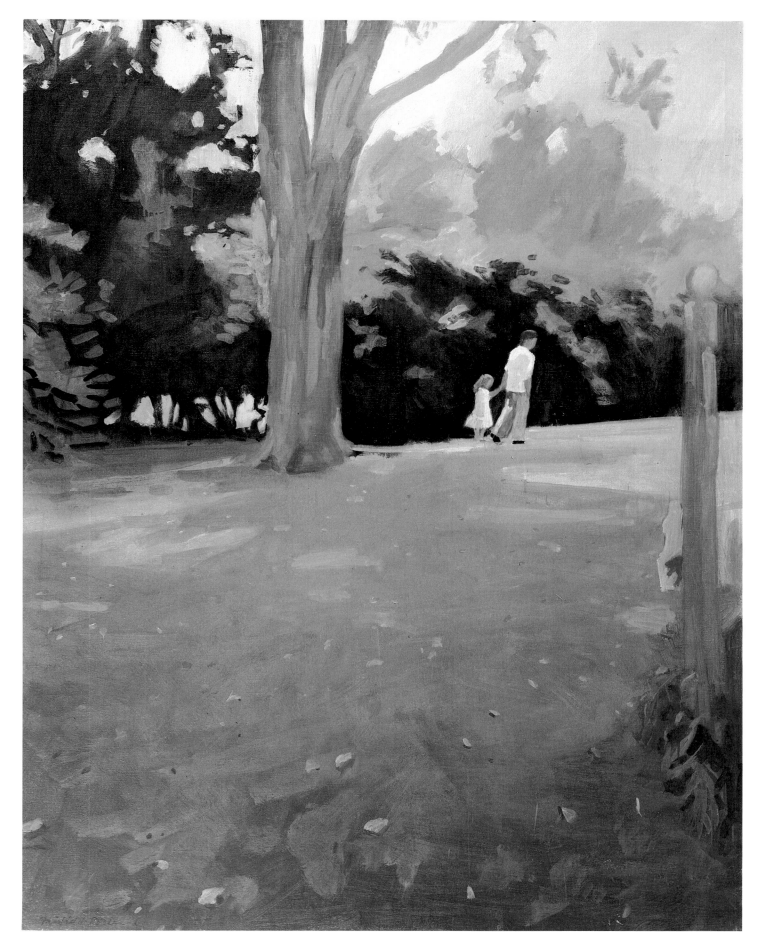

39. *A Short Walk, 1963*

Once Porter began to raise his sights, his conservatism and reticence became his greatest assets. For if this was a period of great excitement and growth in American art, it was also one of great confusion. The American artist asserted himself and finally won a place in American society. But during this same period many artists lost their way through over-assertion. This was true of most of the 10th Street painters like Rivers and Katz, and it became true even of de Kooning after 1950. Pretentious over-assertion became the main expressive feature of much of the American contemporary art that followed in de Kooning's wake (e.g., Pop or Minimal Art). Porter's tact and traditionalism were a positive advantage in this context. He took a long time to become assertive and he never overdid it. Once he started to be bolder, his taste, his intelligence, and his traditional pictorial instincts helped make him the best realist of his generation and one of the finest we have had since the war.[8]

Despite Porter's early attraction to Vuillard, it was only after 1950 that Vuillard's influence becomes strongly visible in his work. We see it most in the comfortable, bourgeois domesticity of interiors: the way he used the horizontals and verticals of the room as well as the central table to organize the whole; the way he scattered objects across a table top or placed a figure behind it or a lamp above it; the way he liked to play with

views through doors and windows. But never is there a self-conscious reference to Vuillard or any older master. We can see in Porter what he said of John Button: "He is a realist, and you do not feel the comparisons with the past or present tradition as relevant since originality is not proclaimed; the only way to regard his painting is as though here painting begins again."

For the most part, Vuillard taught him how to be natural. ("What I like about Vuillard is that what he is doing seems to be ordinary, but the extraordinary is everywhere.") Porter adopted Vuillard's full, traditional range of subject matter: landscapes, interiors, still lifes, and portraits. As with Vuillard, these are always chosen from the familiar and close at hand; his family and friends appear in the figure pieces; the landscapes are of Long Island, where he lived, or Great Spruce Head Island in Maine, where he spent his summers. Never do we get "studio" subjects like the set-up still life or the posed nude. He wanted to avoid the prepared or arranged look. His figures are relaxed but still and quiet, posed or semi-posed and flat-footed. Everything is natural, normal, and as straightforward as possible. The psychology aimed at is always direct, warm, and uncomplicated. The real subject matter is the entire scene and its peculiar effect of light. This subject matter conspires with his sense of form to create the bright "impersonality" and "understatement" of his mature work. The picture has its opacities and densities (its structure), but it is also delicate, soft, and luminous. Porter's color, which had been pallid and dim in the 1940s, is now his strong suit. His soft, pale hues become the freshest and most distinctive feature of his art. They go

a broad, heavily pigmented realism from Abstract Expressionism: the Bay Area School of Richard Diebenkorn, Elmer Bischoff, David Park, and others. He found their structure too "unclear" and their handling too much a "performance."

8. The other contenders, Horacio Torres and John Graham, both have a much smaller *oeuvre* and seem more European than American.

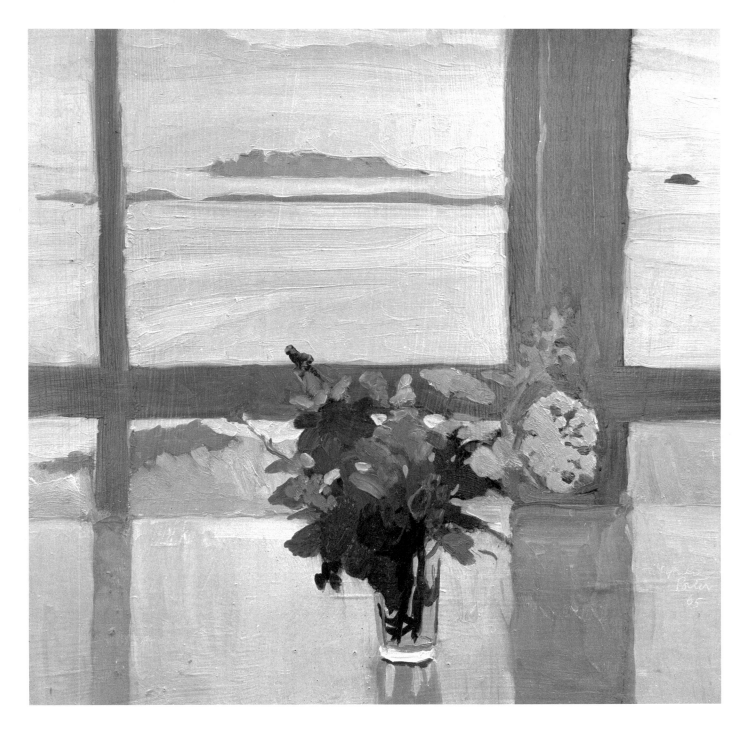

48. *Flowers by the Sea*, 1965

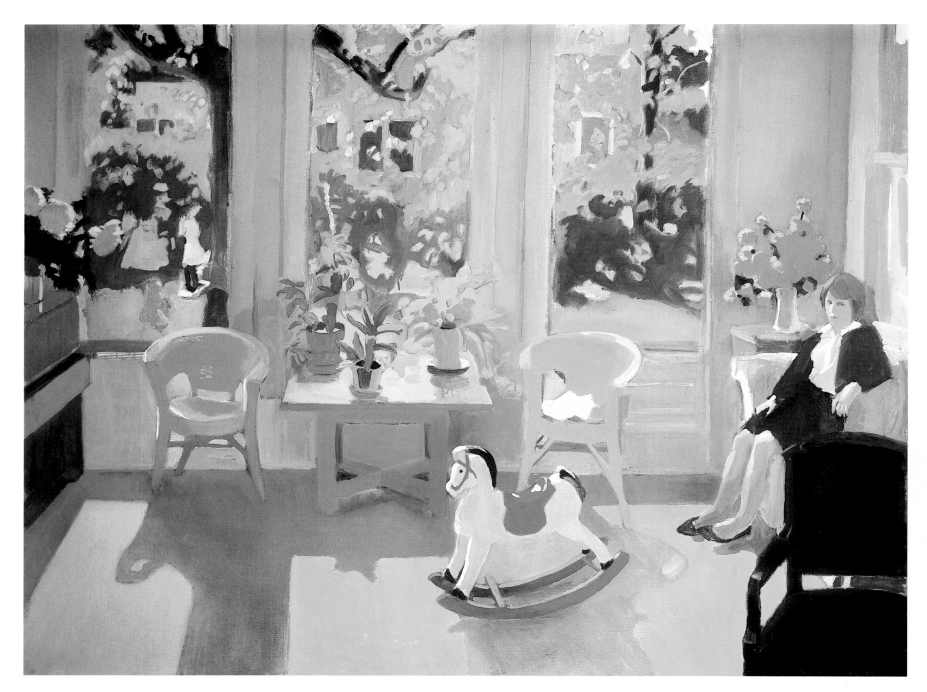

42. *October Interior*, 1963

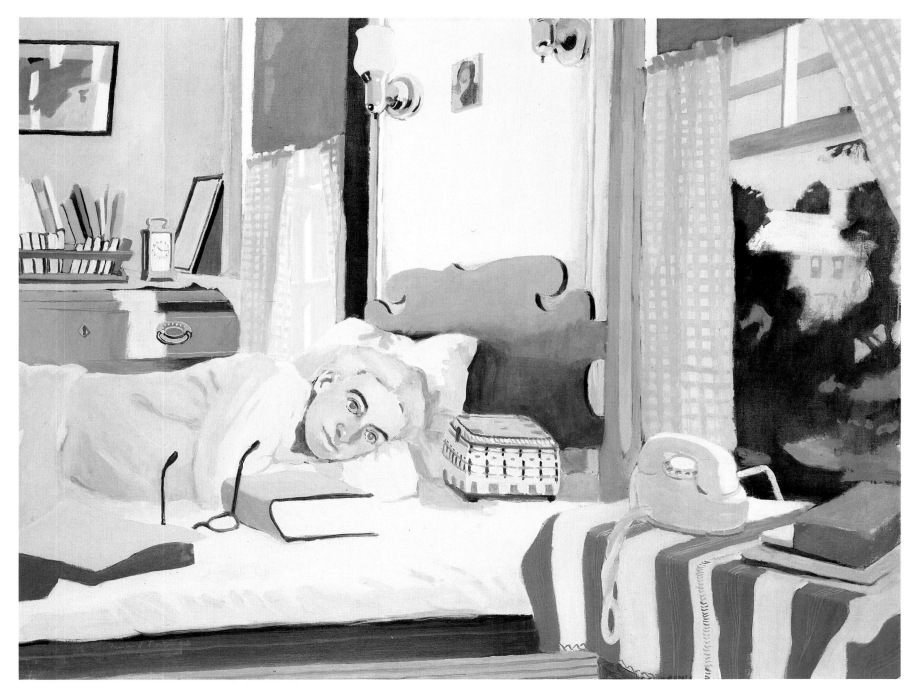

44. *July Interior,* 1964

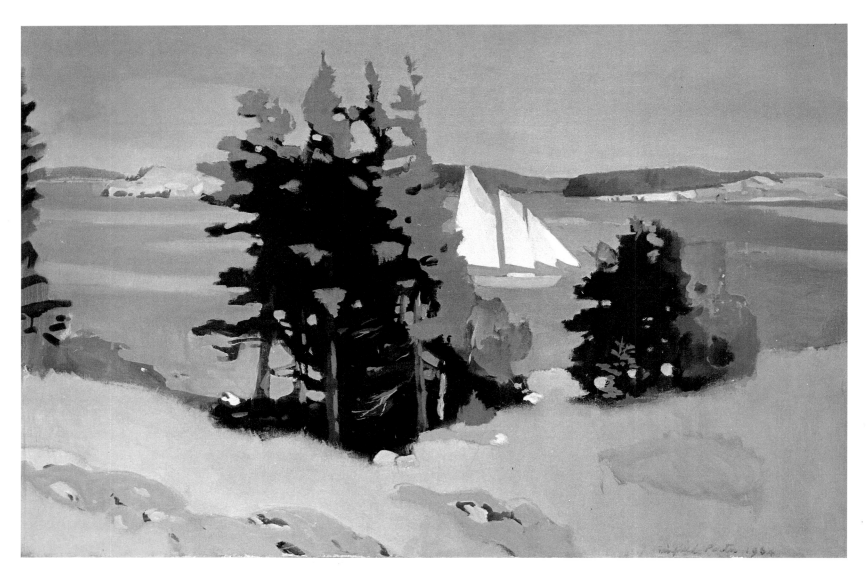

50. *The Schooner II*, 1964

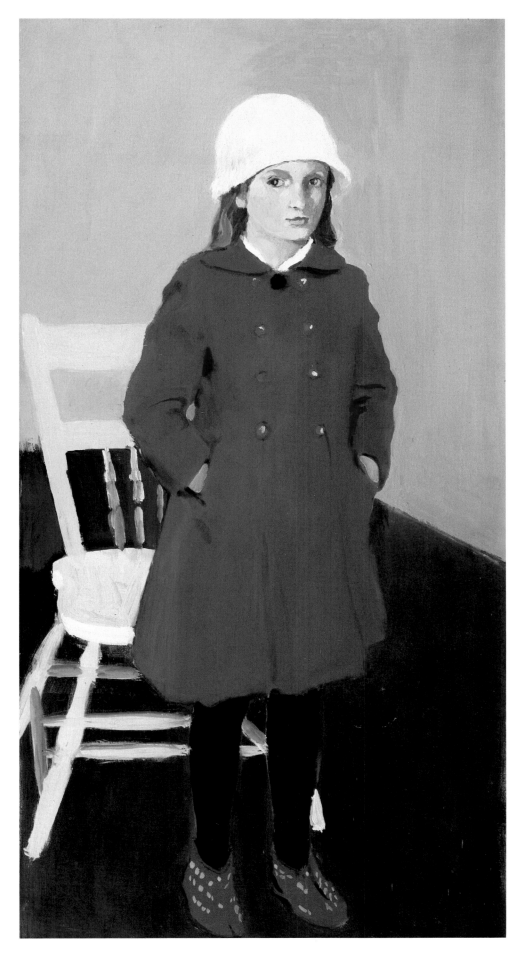

47. *Elizabeth,* 1965

with his taste for dry, matte surfaces and a rough, "artless" touch.

In certain very late pictures, Porter started to cross the border between Impressionism and fauvism, between a reaction to natural light and a search for invented color. Examples include *Beginning of the Fields, Sun Rising out of the Mist,* and *Violet Sky,* where the colors are salmon, violet, peach, and pink. Or he could become sharply acidic, as in *Under the Elms,* a picture that especially engaged him. Porter's drawing is never as willfully inventive as this, but it, too, becomes progressively freer. In his later years, he said that his art history training at Harvard had held him back as regards drawing and composing. Art wasn't first of all a question of rhyming or ordered relations (i.e., of harmony) but of spontaneity and life.

Despite the fact that Porter's main artistic attitude is French or "Mediterranean," his mature paintings ask to be considered in the context of American art.[9] Most obviously, they relate to that American realist tendency we find in Homer and Hopper. Porter once criticized Eakins for his lack of outdoor light and it is, above all, the outdoor light that relates Porter to Homer and Hopper: flat, hard, and clear, it is northeastern light, which Porter once complained about, saying it was boring. (He also called it "knife-like.") It is not that Porter was influenced by Homer or Hopper, but that all three were American realists who found the same thing. With Porter, this light was explored for its own sake and for what it did to color. Porter made this light softer and warmer and he gave up more to the sensual properties of paint; he was more French. Still, compared to the French — to, say, Vuillard — Porter seems tight, crisp, cool, and spacious. His light is more brilliant, his colors contain more white. Earlier American followers of French Impressionism made of it something narrower and smaller. Porter made it something rougher, brighter, broader, and more distinctively American. He saw his surroundings through the medium of paint and so became a "painter's painter," admired for the boldness and sensitivity visible in the aesthetic choices, especially the handling, color, tone juxtapositions, and "weights." This is very much what Porter's pictures are about. For all of their tact and understatement, Porter's mature paintings can be very bold when it comes to painterly values. His pictures seem ordinary, "but the extraordinary is everywhere."

9. Porter saw himself very much in the context of the history of American art and often wrote about older American painting. Almost always he was critical, complaining that America had lacked "generally held standards" in painting. American art was full of "false feelings," and it tended to be "too restrictive of its means." The American artist had been "shy and graphic" or "provincial and imitative" or "eccentric and shallow." Here is a quote from a letter to Armistead Leigh, dated May 15, 1972: ". . . there are times when all American painting between the Civil War and the Second W.W. is hateful to me. Exceptions: Marin, some of Prendergast's watercolors. What I hate is the Puritanical idea that light is of no account, that pleasure condemns you to hell, that life is empty of daily significance; everything has to be essential." Porter saw the history of American art the way he saw Eakins: as the struggle of instinct with conscience.

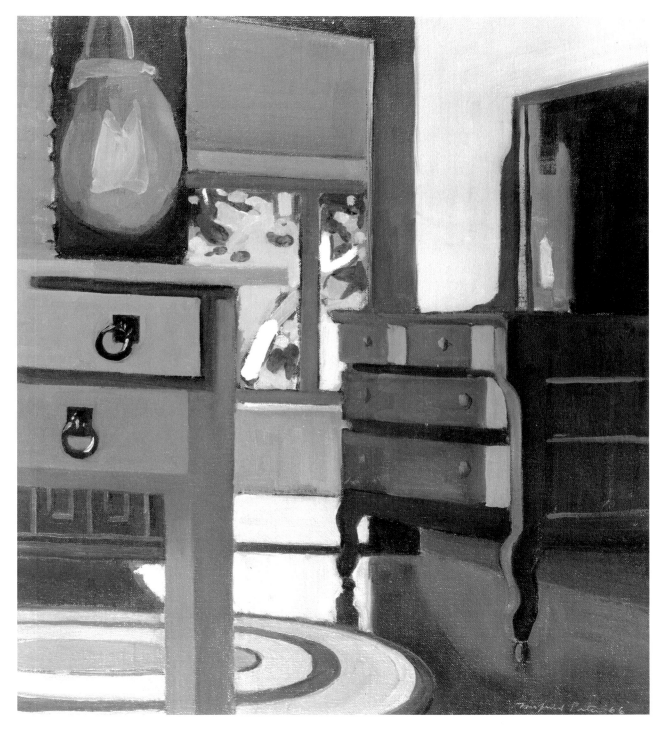

57. *Early Morning, 1966*

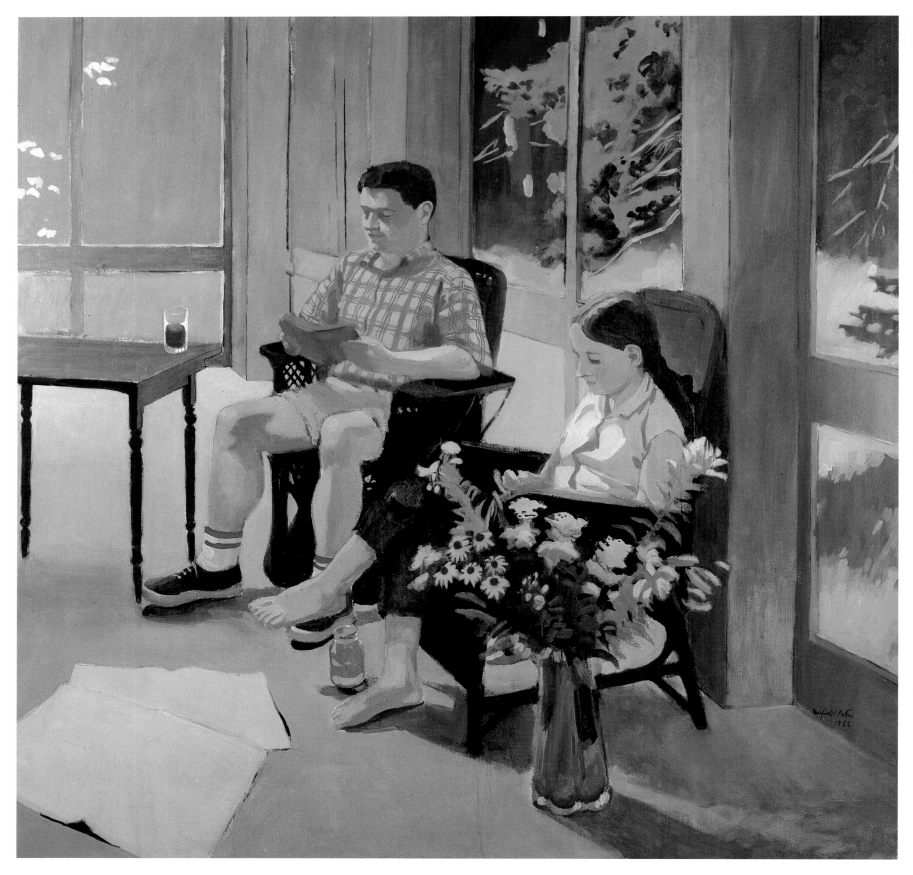

58. *Iced Coffee*, 1966

* *

Jottings from a Diary (1952-1975)

by John Bernard Myers

"And how did you happen to show Fairfield Porter as far back as 1952?" the critic Grace Glueck has asked me. My gallery, I explained, was initially located on East 53rd Street near Third Avenue. We hadn't been open for more than a year when the painter Bill de Kooning paid a visit. De Kooning, along with Pollock, occupied a special niche in my personal rostrum of splendid New York artists, someone to whom one paid heed. "I've got a really good artist for you," he announced shortly after he sat down. Almost everyone I knew was giving me suggestions as to who ought to be exhibited; I was getting hardened to so much helpfulness. "And who might that be?" I asked politely. "Someone who knows how to paint really good — Fairfield Porter." I looked skeptical. "Come on, Bill," said I. "Aren't you pushing one of your friends?" De Kooning became animated, emphatic. "Yes, he is a friend, but I'm telling you Porter is really good. He knows what he is doing!" I was so impressed by de Kooning's warmth and sincerity that I did something I had never done before. "Very well," I said, "if you are that positive we'll show Porter's work — sight unseen."

A few weeks later, Porter showed up with a half-dozen canvases, which, to my bewilderment, were neither abstract nor Expressionist. What he had brought were naturalistic still lifes and landscapes, rather dark in color and not very alluring. I felt uneasy, but I had given my word. A few months later we installed Porter's first show. I feared I had made a stupid mistake, but after about a week of being with the pictures and looking at them daily, I found that Fairfield Porter was exactingly the artist de Kooning had praised as "really good."

* * *

I have been visiting in Southampton and have come to know where Fairfield Porter lives and works. His studio is in a large barn at the back of his property on Main Street. The upper part is for painting, the lower is mostly a storage area for tools, machines, household implements. When I call on him in his studio I discreetly do not look at pictures turned to the wall. Often there is the awful smell of Maroger's solution boiling in an iron pot. This is Fairfield's favorite paint medium because, he explains, it has a fine transparency, slides onto the surface easily, and dries slowly. He has, of course, experimented with conventional oils and even acrylics but finds them inadequate for the effects he prefers. Maroger's solution does not inhibit his spontaneity or fresh ideas as he is working. When a canvas refuses to "jell," Fairfield simply discards it and starts another. Luckily this does not happen often.

* * *

Someone who has never laid eyes on Fairfield Porter asked me what he looks like. All I could think of was Henry Fonda — especially the way he walks and moves. Both Fairfield and his photographer brother Eliot look like Henry Fonda. However, the resemblance is superficial; Fairfield has no patience with creating illusions. He dislikes having his portrait painted and loathes being photographed. He has, however, done one quite fine self-portrait, which he can't imagine anyone buying.

* * *

There is a sense in which Fairfield is never quite *with* one. He engages in discussion with intensity, says what he has to say with animation, is suddenly silent, looking elsewhere, or, from time to time, stares piercingly at the person to whom he is speaking. It's put up

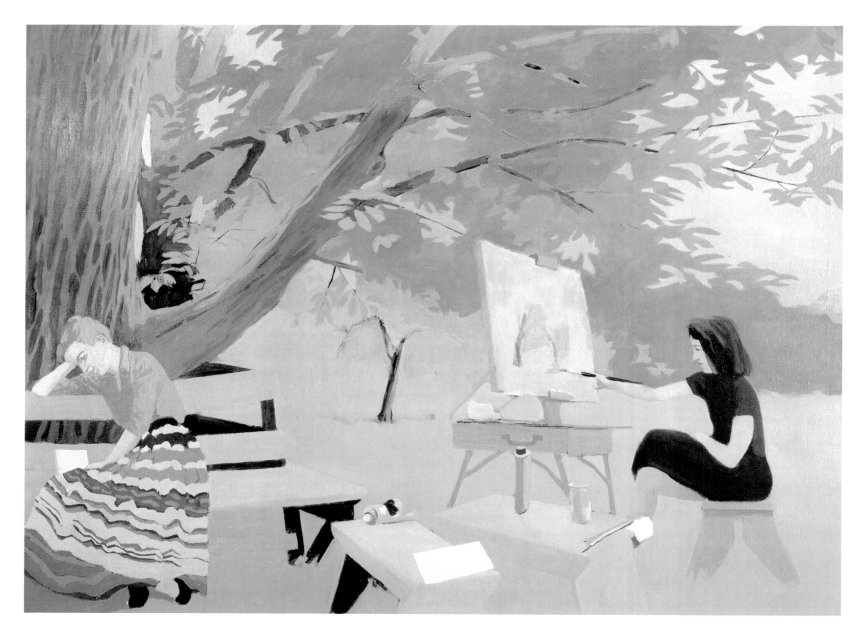

63. *Nyack*, 1966-1967

or shut up. At the same time, his detachment is almost planetary, with him on the other planet. Archimedes point?

* * *

FP: "It is fashionable to declare that there is no longer an avant-garde. Ridiculous! There will always be one, if we define the avant-garde as those people with the most energy."

* * *

FP: "I never was one to paint *space.* I paint air."

* * *

I have asked Fairfield if he would consider repainting a small drip, which bothers a collector who has lived with the picture for many months. In fact, the collector's obsession with this small drip baffles me. However, I dutifully reported the complaint.

"What a silly request! I would no more change that area than I would think of removing a mole from a beloved's face."

* * *

Looking at *The Pear Tree,* a large landscape, I observe that the shadows of the tree, the figure, the house, and the chimney on the house all fall in different directions. When I point this out to Fairfield, he rather testily replies that he could show me a Titian, a Caravaggio, even a Rembrandt, where the shadows fall in sixteen "wrong" directions.

* * *

I was amused by a conversation Fairfield had with his eleven-year-old son Jerry, in which the question was asked: if a super hydrogen bomb was tested near the equator, would this not throw the earth slightly off its axis? Jerry promptly said, "Not at all, no more than if you dropped a bee-bee into a whirling gyroscope." An expression of warm approval passed over Fairfield's countenance. Or, should one say, admiration? The extraordinary intelligence of his children delights him.

* * *

I was wondering how Fairfield would react when his six-year-old daughter Katie was about to follow her mother, Anne, into the Roman Catholic faith. Before taking instruction from her spiritual adviser (a Miss Kelly, very close to John XXIII in point of view), Katie asked her father if he minded. "Why should I?" he replied. "After all, it's your business." What charms me is that so few people I know who are freethinkers or atheists have Fairfield's tolerance for beliefs that are radically different from his own.

* * *

FP: "The important thing for critics to remember is the 'subject matter' in abstract painting and the abstraction in representational work."

* * *

I am no longer surprised that Fairfield has so much respect for the Abstract Expressionists and many other artists who work far differently from the way he does. I would, however, have thought that the constructions of Joseph Cornell had little appeal for him, since he does not see the world in the sense that

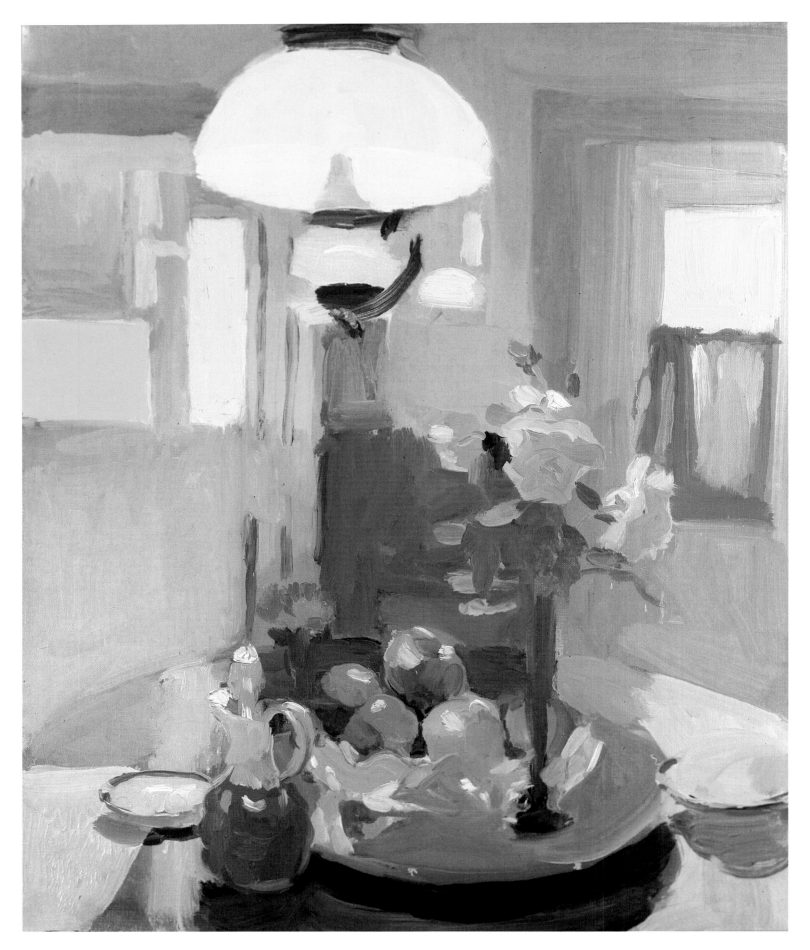

64. *Apples and Roses, 1967*

Cornell imagines it. Of course, I am quite wrong. We have had several long conversations about Cornell's boxes and the sources of his imagery.

I confided that I had been keeping a count on the "props" Cornell used — marbles, jacks, watchsprings, sea shells, compasses, etc. — and that there were fewer such objects than it would appear. There seemed many more because of their subtle relationships, their elusive "correspondences." Fairfield had already observed and understood Cornell's extraordinary "put-togethers." More important, he appreciates the nineteenth-century romantic poets by whom Cornell is often inspired. He has, for instance, been reading texts by Gérard de Nerval — one wonderful clue to Cornell's mysteries.

* * *

Art and Literature, the quarterly so well edited and printed by artists Rodrigo Moynihan and Anne Dunn, has published a remarkable essay on Cornell by Fairfield. Cornell detests almost everything that has been written about his work, but not this essay; he feels it is the first article that comes close to what his constructions are about.

* * *

Although Fairfield has been with the gallery for almost ten years, I cannot say we have had much luck selling his work — a few paintings, a few drawings. His work seems too low-keyed for the sort of buyers we attract; abstract or fanciful pictures are more acceptable to the present public.

But then the other day Blanchette Rockefeller, Mrs. John D. Rockefeller III, came to the gallery. She had heard about Fairfield's paintings and thought they might be suitable as gifts, one for her husband and the other for a secretary who is getting married. Since I have come to know Blanchette through parties and openings at the Museum of Modern Art, I admire her elegance and her enthusiasm for contemporary art; further, she has a "good eye" and I was pleased by the selections she made. I daresay many more collectors will follow suit.

* * *

A collector has asked me what the "abstraction" *is* in Fairfield's work, and I suggested that we look at some of his drawings. It then becomes clear that a tree, a shoreline, a house, dishes on a table are not simply delineated; he apprehends such subjects by drawing the space around them. He seems to perceive forms *backward.* (I think art-instruction texts call this "negative pattern.") It is a method for discovering shapes and arrangements that are as "abstract" as any by, shall we say, Kline, de Kooning, or Baziotes?

* * *

Few painters I know are as intelligent and well read as Fairfield Porter. Perhaps attending lectures by the great philosopher Alfred North Whitehead while he was a student at Harvard College gives him the intellectual *panache* that is so admirable in his critical pieces for the art magazines and *The Nation.* His prose is crystalline, a combination of clear thinking and good manners.

Imagine my astonishment when Fairfield came into the gallery yesterday and fulminated against the American Medical Association for forbidding the distribution of a "very important new drug." "What is it for?" I inquired. His voice rose. "For the cure of cancer! It can be made quite cheaply from apricot pits." "A cure for any kind of cancer?" Fairfield shook his head affirmatively and said, "Absolutely." "And

what do they call this miracle drug?" I wanted to know. "Laetrile," he answered. "Laetrile."

* * *

Why should I find it strange that Fairfield could be ingenuous about such a nostrum as Laetrile? He has also told me that a mixture of apple-cider vinegar and honey drunk every morning before breakfast is a cure for arthritis. Our many conversations often show him to be against what he terms "scientific progress." He dislikes much of modern technology and sincerely believes it will bring all of us to ruin. He refers to atomic weapons, pollution, overcrowded cities, super highways, and other abominations as horrors brought about by scientific advances. I find this opinion retrogressive, but Fairfield thinks like an artist and never arrives at a conviction without much reading and cogitation. I agree with him about the abominations, but I am not convinced that the misuse of science can be held against responsible scientists.

Fairfield believes that art holds much that is true but not explainable. He is disdainful of any tightly held theories. Often he says, "No theory is any good unless it remains open to being disproved."

* * *

Why in the world is it that Fairfield never says goodbye when he visits the gallery? Suddenly, there he is, and just as suddenly, he's gone!

* * *

Anne and the children have received permission for a Requiem Mass to be said for Fairfield in the Church of the Sacred Heart of Jesus and Mary in Southampton, where he will be buried in consecrated ground. A few weeks previously, he was observed by his daughter Elizabeth reading *Revelations of Divine Love* by Juliana of Norwich.

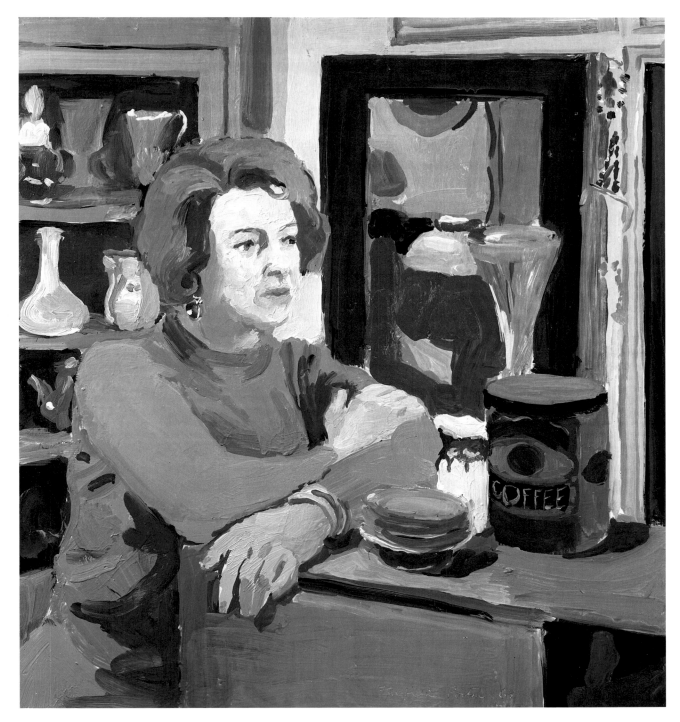

71. *Inez MacWhinnie,* 1968

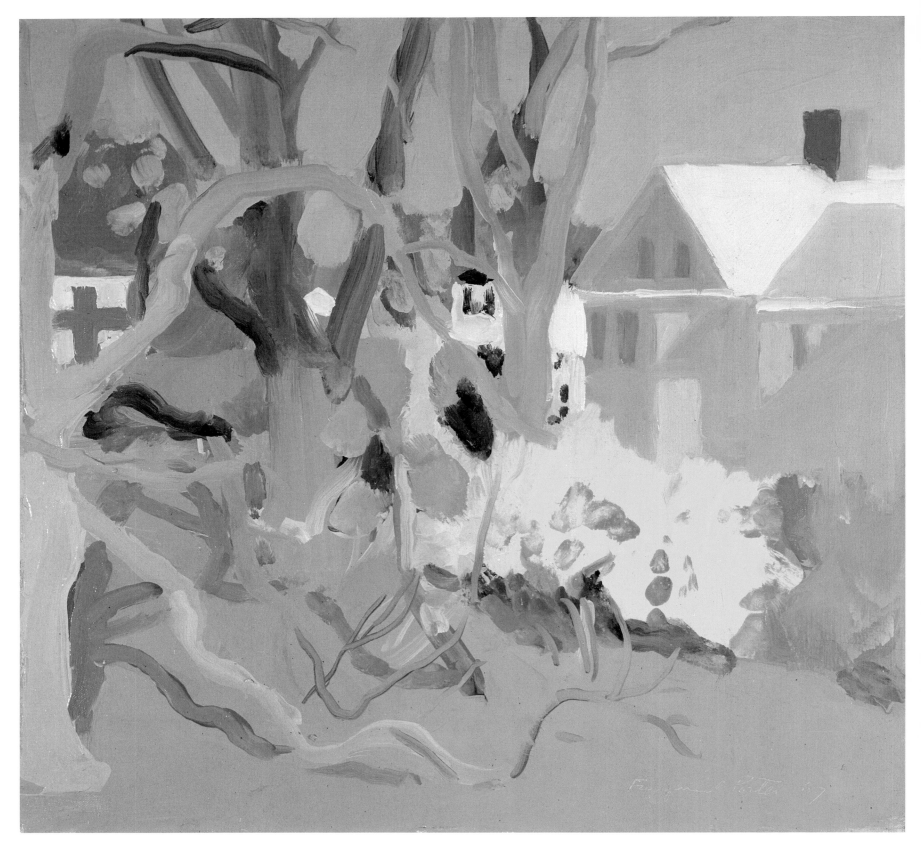

67. *Spring Landscape,* 1967

* *

Conversation with Fairfield Porter

conducted by Paul Cummings

The following interview took place with Paul Cummings (now Adjunct Curator of Drawings at the Whitney Museum) on June 6, 1968. The full text is available through the Archives of American Art.

* * *

PC: When did your interest in art begin?

FP: Well, children like to draw, and I sort of stuck with it for some reason. I don't know why. I think I might have had literary interests, except that I read very slowly. I managed to do very well in school in spite of that.

When I was twelve, I was taken to the Chicago Art Institute by my mother, and I remember I always liked to see paintings. Among the paintings I remember in the Institute are Giovanni di Paolo's *Beheading of John the Baptist*, which was sort of fascinatingly gory. And Rockwell Kent I liked very much. And about that time, when I was twelve or thirteen, an exhibition of Pablo Picasso, the Egyptian period, those great big heads. That impressed me very much. I thought if this is what painting is, it's a significant activity. I copied Howard Pyle and I copied photographs.

PC: How would you evaluate the art education you received at Harvard?

FP: I don't think I could have gotten a better education anywhere else at that time as far as history is concerned. But in aesthetics it was weak; there wasn't any relation to practice. It was theory, superficial theory. I found that out much, much later when I met Willem de Kooning. First I thought I had found it out when I studied with Thomas Hart Benton. He seemed to go further. But then, when I met de Kooning, I thought Benton was not too deep.

PC: What kind of theory did you find, or did you acquire at Harvard?

FP: Well, they would say, "Here's the surface of the painting. And this is well composed." Composition is the most important thing. And composition means that they analyzed it — I think Professor Pope did too — repetition and sequence and probably another thing, I don't know what — harmony, maybe. And I found out many, many years later that composition isn't good because something is repeated but because it is not repeated. It was just the opposite. If there's something that never occurs again in a painting that's what is its unique quality.

PC: Was there anyone there interested in modern art at that point — the late 1920s?

FP: Arthur Pope. He explained cubism to us in an interesting way. Analytical cubism, he said, was like jazz. An intuitive remark, but I think it's true. And we were presented with the aesthetic theories of Bernard Berenson, which had a very strong influence on me. Even today, I look at Florentine painting in Berenson's terms.

I met him when I was in Italy in 1932. I remember telling him that I liked Tintoretto and Rubens because I'd learned to like them from Thomas Benton. And Berenson said he knew what I meant about them, but the best painter of all was really Veronese, or Velázquez. At that time I didn't like either of them. But now I do. I think I like Velázquez better than any other painter.

PC: When did you make that discovery?

FP: After the last war, there was a show of the paintings from the Kaiser Friedrich Museum at the Metropolitan and there were some Velázquez *infantas*. I'd seen them before in Berlin. I was beginning to be

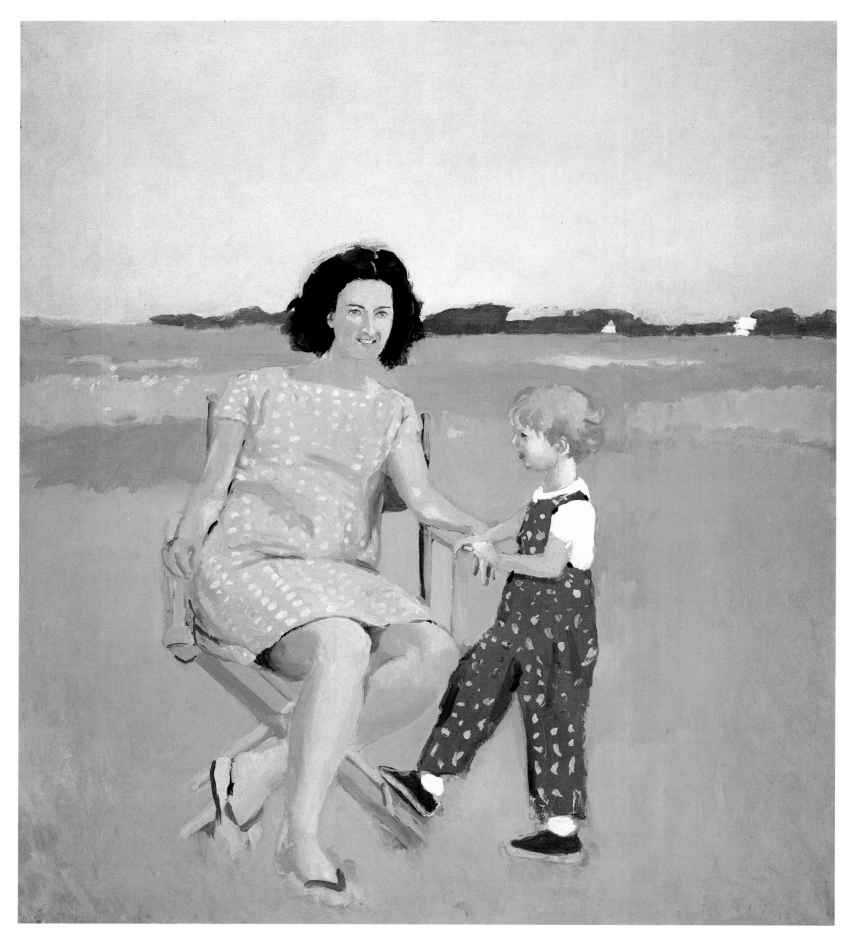

65. *Jane and Elizabeth,* 1967

interested in what you can do with paint — what is the quality of paint, what is its nature. And I admired the liquid surface of Velázquez. And what might be called his understatement, though I don't like that word. The impersonality — I don't know what word to use. He leaves things alone. It isn't that he copies nature; he doesn't impose himself upon it. He is open to it rather than wanting to twist it. Let the paint dictate to you. There's more there than there is in willful manipulation. I used to like Dostoyevsky very, very, very much. Now I prefer Tolstoy for the same reason. He is like Velázquez for me.

What I like in painting — partly what I like in painting — is to rationalize what I like. The artist doesn't know what he knows in general; he only knows what he knows specifically. And what he knows in general or what *can* be known in general becomes apparent later, through what he has had to put down. You are not quite in control of nature; you are part of nature. It doesn't mean that you are helpless, either. It means that the whole question in art is to be wide awake, to be as attentive as possible, for the artist and for the person who looks at it or listens to it.

PC: Yes, I see what you mean. Well, was there anyone besides Pope at Harvard who you feel was influential?
FP: Arthur Kingsley Porter, who gave a course in pre-Romanesque art. It wasn't a set course. He didn't know everything yet. It was as he was discovering things that he gave them to us. We were sort of watching his research. And I took a course with Whitehead in philosophy. And that was very, very interesting. And Langer in history; he's the ex-husband of Susanne Langer, the aesthetician.

PC: How did you like Boardman Robinson and Benton as instructors when you were at the Art Students League?

FP: I liked Robinson best. He was a teacher. That is, he taught *you*, he didn't teach a system. He taught the person he was talking to. He never seemed to repeat himself. I listened to his criticisms as he went around the class. There were things he said again and again, but there was always something new. Whereas Benton presented the same system to everybody. And then you did it or not.

Robinson was a more interesting man than Benton. In life, too. He was interested in lots of things. He would bring ideas from the outside to the class. Benton's style as a man was to present a body of knowledge three feet long and three feet wide and one foot thick, and that was it. He had what James Truslow Adams calls the "mocker" pose. He liked to pretend; he liked to act as though he were the completely uneducated grandson of a crooked politician. I found that sort of tiresome.

There were life classes. There was drawing. Nobody taught painting. You could paint if you wanted to, but there wasn't anybody at the League who knew how to paint. None of the teachers did. I don't think anybody in America knew how to paint in oils at that time. Maybe John Sloan did. But he put it aside later on, didn't trust it. But there was something in American art at that time — the Armory Show was a complete disaster to American art, because it made people think that you *had* to do things in a certain style, and they gave up what they did in order to do this new thing. It was a little bit like selling whiskey to the Indians. A few painters got something from it, got a lot from it. John Marin got a lot from it. But American art was provincial before, and it became more provincial as a result of the Armory Show. Of course, there were people who were — provincial might mean dependent on somewhere else, or it might mean isolated from the world. In the latter sense, there were certainly very good painters in America. But they weren't in the mainstream.

PC: Who would you say was in the mainstream in the 1920s?

FP: Marin. The people Stieglitz showed. Benton, Kenneth Hayes Miller, I suppose, in this country. Sloan. And the illustrators of the American scene. They were naturally good painters; they had native talent, and they knew better than they thought. They didn't have any confidence. They couldn't keep on. They didn't know what to do next.

PC: How about Robinson's painting?

FP: No, he wasn't any good as a painter. He's a more interesting draftsman. I heard that Virgil Thomson once said — I think in the 20s — that the center of intellectual life in Vienna is composers or musicians; in France it's the painters, perhaps — I don't remember; in America it's the journalists. That was in the 20s. And so journalism was somehow the way that painters got a connection with the world. And cartoonists, for instance. *The New Masses. The Masses.* Radical journalism. Or else the American painters were expatriates or they were isolated. When Eakins died — I think he died about 1910, I'm not sure — he was completely isolated.

PC: Marin was to an extent, although . . .

FP: . . . he sold well and lived well.

PC: But Dove certainly didn't live very well. He had a terrible time.

FP: He had original ideas, as original as any ideas in France. But that wasn't enough. You have to have more than that. There wasn't anything natural he could do about these ideas. He couldn't do anything except isolate himself further. The really modern ones like the Stieglitz group, as opposed to the newspaper illustrators and that whole Philadelphia crowd, were so distant from each other. The newspaper people like Luks and Sloan were so involved with the sociology of the street — done in oil paints — rather than with painting problems and art situations; where it showed, for instance, was in Bellows, who was a very, very talented person. The journalists took him up. He was the favorite of the journalists. He himself wasn't an artist-journalist but he was a journalist's artist. And then he began to read books about art theory and so on and his painting just became no good at all. He applied theories of dynamic symmetry and of color and so on and so on, instead of having a direct contact through his sensibility with the medium and with the picture. They didn't believe in themselves, in other words. They always had to look elsewhere for reassurance and confidence.

PC: Was it at the League that you began to meet other painters and get involved in the art world in New York?

FP: I met Marin in about 1938 or so, in New York. And I also met Paul Rosenfeld, who influenced me very much as a critic — his gift for language, for being able to describe what something was like, to put it into words. When I wrote criticism I was thinking of his criticism. Not just of Berenson. I remember things that Rosenfeld would say. I remember telling him I didn't like Odilon Redon, and Rosenfeld said, "What's the matter? Is he too ultraviolet?" And I thought that was exactly it! He had an impressionistic way of talking that was extremely accurate. Beautiful.

PC: You had an early interest in language, it seems?

FP: I guess so. I got that from my mother. My mother always had an interest in language. She wrote very good letters.

PC: When did you start writing?

FP: Not till after the war. I started writing art criticism. I got into it through Elaine de Kooning, who had been a reviewer on *Art News*. We went to a show

at the Whitney Museum, a retrospective of Arshile Gorky. She talked to me about how good his things were. And I talked to her about how bad they were. We had a complete thorough disagreement about them. Apparently I expressed myself so well that when she was leaving *Art News* and Tom Hess asked her who she could recommend as a reviewer, she recommended me. I jumped at the chance. I had always thought that I would be good at it, better than anybody. I had always thought that. And they liked me right away at *Art News*. As a matter of fact, Alfred Frankfurter, who was the editor-in-chief then, said, "He's so intense, I give him a year." I stayed for about seven years. And I could have kept on forever. Partly because I was painting, which would give me new ideas. You see, if you're not painting and you're a critic, you might get to an end and have to repeat yourself. I got ideas all the time for what I was doing, which renewed me.

PC: So as the painting developed, the criticism would change and evolve.
FP: Yes. And I'd go around to artists' studios and look at their work. The reason I was good was that my method was, I suppose, tentativeness. I would try as much as possible, when looking at something that I had to review, to cease to exist myself and simply identify with it, so that I could say something about it. I learned that because I was told to do it (not in those words) by my editors. Frankfurter said what I should do is just report, that the best criticism is simply the best description. And I think that is true.

I am somewhat in awe of any writer of poetry. I got in connection with the Tibor de Nagy Gallery (which published Frank O'Hara, John Ashbery, James Schuyler, and Kenneth Koch) through Larry Rivers's and Jane Freilicher's and Bill and Elaine de Kooning's recommendations. After I had been writing for *Art News* for a month, I wrote a review of one of the gallery's first shows. I thought it was the liveliest

gallery in New York, that it was the place I would like to be in. So I got just exactly what I wanted.

I got in the Tibor de Nagy Gallery in 1951. They gave me a show. It was some new pictures and some old pictures, and it was kind of scrappy. But people were interested — I think because it was realistic and realistic in a different way from what they were used to. And artists were interested. They kept coming to those shows. They'd ask abstract artists like Jack Tworkov if there were any realist artists there. And he'd answer, "Well, there's Fairfield Porter." Some of them accept me; some of the abstract expressionist painters do accept me. In a way, I feel more at home with them than I do with people who aggressively call themselves realists. I don't feel at home with them. I don't feel at home either with people who aggressively call themselves abstract, like the American Abstract Artists. I couldn't have any connection with them.

PC: What kind of writing did you do for *Art News*?
FP: Well, they saw what I wrote about, and Tom Hess would think of things for me to do. I had a feeling that I was typed as the person to write about American art. I think it was because I didn't like American art. I thought I didn't like it very much, so I was a little bit less enthusiastic. My reviews were more critical, maybe more interesting, for that reason. So they gave me John Singer Sargent to write about, a big show of Sargent in Boston. And George Bellows, whom I put down. But they wouldn't give me the people I really would have liked. They did give me Winslow Homer, whom I was glad to write about. And Marin, whom I still have a kind of filial feeling toward. I don't know how much I like his pictures, but I can't ever get over the memory of how much he meant to me at one time.

PC: Do you think that reviewing had an effect on your painting?
FP: Yes. It did have an effect on my painting. Not just

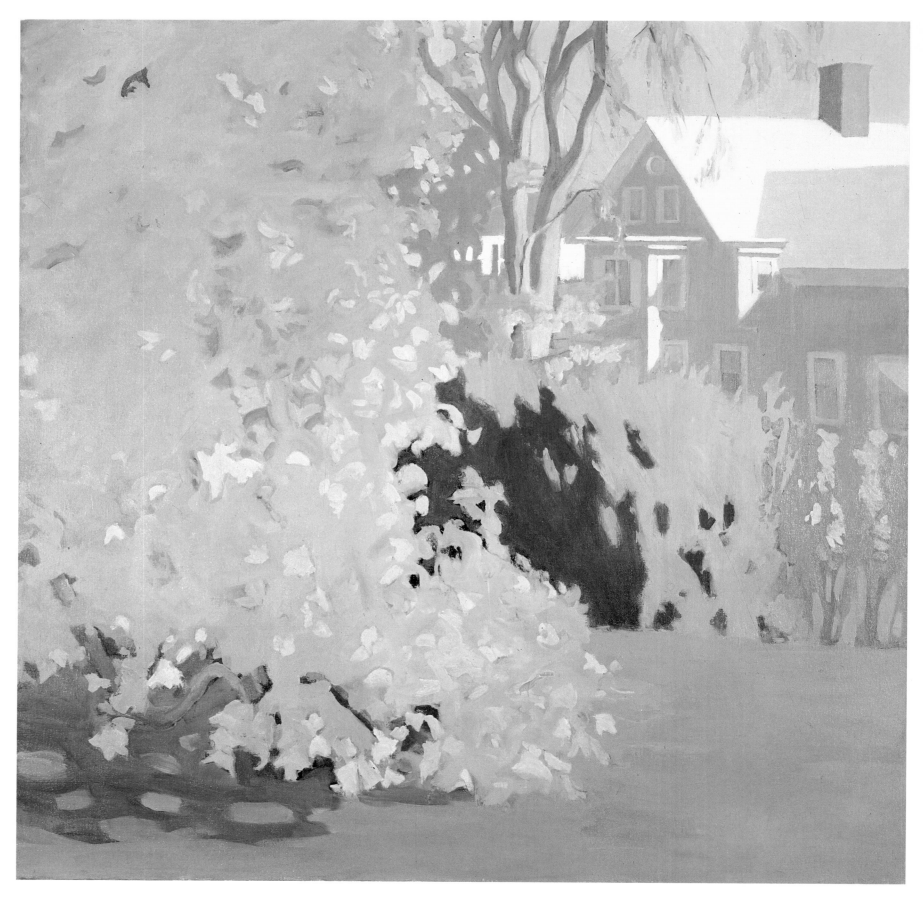

69. *Columbus Day, 1968*

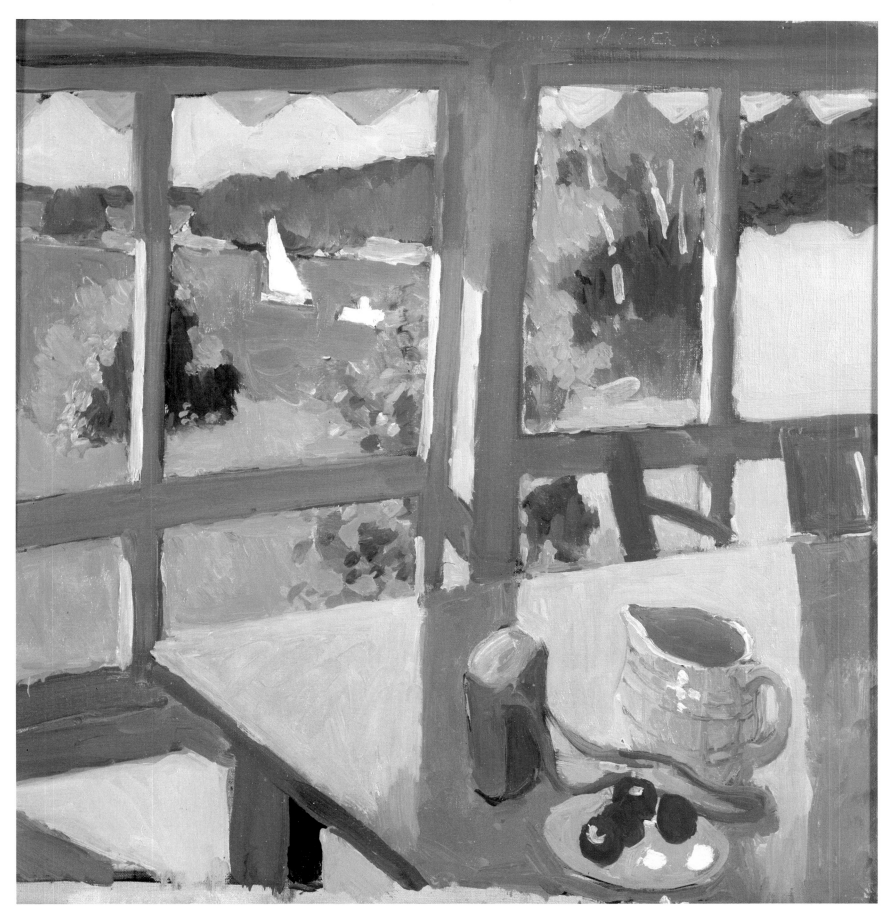

74. *Still Life With White Boats,* 1968

writing, but looking at things. I would think about something that I was writing about, and then I would think: If this is the way, why are they doing such and such? Then I'd have a look at my own painting and think: Why am I doing this? Why can't I do it differently?

PC: How, at this date, would you evaluate your art school education and training? Do you think it did much for you?

FP: I think the historical part did most for me. I think I learned most as a painter from paintings, or I learned most as a painter from de Kooning and Van Hooten and Maroger and my own contemporaries now, Larry Rivers, Jane Freilicher, Alex Katz, John Button. I've learned a lot from all of those.

PC: You were never an abstract painter, were you?

FP: No. One reason I never became an abstract painter is that I used to see Clement Greenberg regularly and we always argued, we always disagreed. Everything one of us said, the other would say no to. He told me I was very conceited. I thought my opinions were as good as his or better. I introduced him to de Kooning (Greenberg was publicizing Pollock at that time), and he said to de Kooning (who was painting the women), "You can't paint this way nowadays." And I thought: Who the hell is he to say that? He said, "You can't paint figuratively today." And I thought: If that's what he says, I think I will do just exactly what he says I can't do. That's all I will do. I might have become an abstract painter except for that. Another reason I paint the way I do is that in 1938 at the Art Institute in Chicago there was an exhibition of Vuillard and Bonnard. I looked at the Vuillards and thought that maybe they were just a revelation of the obvious, and why did one think of doing anything else when it was so natural to do that. And Saul Steinberg once asked me at a party if I painted the way I did for political

reasons. For a person who's a humorist what a question! So I said, "No, not at all." When Bill de Kooning was first influenced by modern art, it was Picasso whom he emulated. With me it was Vuillard.

PC: Do you make a lot of drawings?

FP: I draw, but they're for my own use for painting. I develop a drawing around a color because it's something to use. That's what I want to know when I look at a drawing. I want to use it for something that's going to be colored. So I give myself that information.

PC: The drawings are studies for paintings?

FP: They're studies for paintings, or they're not studies for paintings. I think some day I might make a painting, or I already have the painting in mind when I make drawings. But usually what I'm thinking of is a painting eventually.

I think I was always very influenced by people's ideas of what painting is, what's important in it. Maybe beginning with Berenson's aesthetic ideas. And then Benton.

PC: How were the early paintings painted?

FP: They were painted in that Benton manner. He said reality is a series of hollows and bumps. He had an elaborate technique that was completely worthless, I think. It had no sense, no sensuousness as far as the medium is concerned. After all, a painting is made of paint. Benton is one of those painters who seems to be trying to overcome that, as though that were an unfortunate drawback. I suppose I was thinking that what I had to do was to learn how to paint. And there wasn't anybody who could teach me. I just had to learn it. So I set about copying the way things looked, trying to get the concept of reality down. Franz Kline once told about a class he had. A lady said to him, "I don't know what to do with this painting." He said, "Well, where you see green put down green, where you

see blue put down blue." And that is true. And it's very hard to do. He hasn't really explained anything, or he's explained everything. One or the other. Nothing or everything.

PC: You've painted a number of interiors and landscapes.
FP: What I think now is that it doesn't matter much what you do. What matters is the painting. And since a reference to reality is the easiest thing, you just take what's there. And then, whether you've made anything or not, you hope it's significant. Well, what is significant? What counts? It's where this aesthetic theory business comes in. What does one think of? For instance, I painted a view recently. A great big painting. And it's because I looked out a window and saw it as if for the first time, in a new way. I saw it as something integral. And so I put this down on canvas. I'm not quite satisfied with it. In a way I like it. It always comes out differently than you think. And I might as well do it all over again. Why don't I do that? That's like inspiration. Again, it interests me to do it. I would do it differently this time, I hope. It would have that "all-at-onceness." What I admire in Alex Katz's paintings is that they remind me of a first experience in nature, the first experience of seeing. And that interests me more than — expressionism doesn't interest me very much, expressionism is a problem. But visualness interests me very much. And it must be that "first timeness" — the world starts in this picture. That's what I'm interested in.

Elaine de Kooning came around and looked at a picture in the studio. She said that that picture interested her because she never in the world would have thought of painting it. That I took as a great compliment. What I like in Vuillard is that what he's doing seems to be ordinary, but the extraordinary is everywhere.

PC: In one show you had a number of interiors. Do you paint the house a lot? I mean you seem very involved with the environment that you live in.
FP: Well, that's mostly the house in Maine. I paint that perhaps a little more than I do this one. And I think that's because it was built by my father. It's an example of his architecture. And so in a sense if I paint that house in Maine I'm also painting a portrait of my father or something like that. . . .

PC: When you do a painting like the self-portrait do you arrange all the things that are in it?
FP: Not very much, no. I see an arrangement that I like, then I — all I did was to arrange that chair for me to put one hand on. Then I thought of that. The rag on the floor was there and I liked it. Often in still lifes — almost always in still lifes — I don't arrange them. This still life was arranged. But usually it's just that the way the dishes are on the table at the end of the meal strikes me suddenly. And so I paint it. Part of my idea or my feeling about form that's interesting is that it is discovered — that it's the effect of something unconscious like, you know, the dishes are in a certain arrangement at the end of a meal because people without thinking have moved things and then have gone away. And I think it's impossible not to get some sort of form if you don't think about it. If you do think about it you can get chaos. But if you don't think about it you get form.

PC: That's interesting. Because it's very kind of arbitrary — you rely on a lot of arbitrary actions of other people.
FP: Well, I have a great deal of personal evidence to support that theory of mine. Like one thing that I like to tell often when I talk to art students. In Maine, for instance, there are a lot of maps around of the islands and the island we live on. And they have a certain

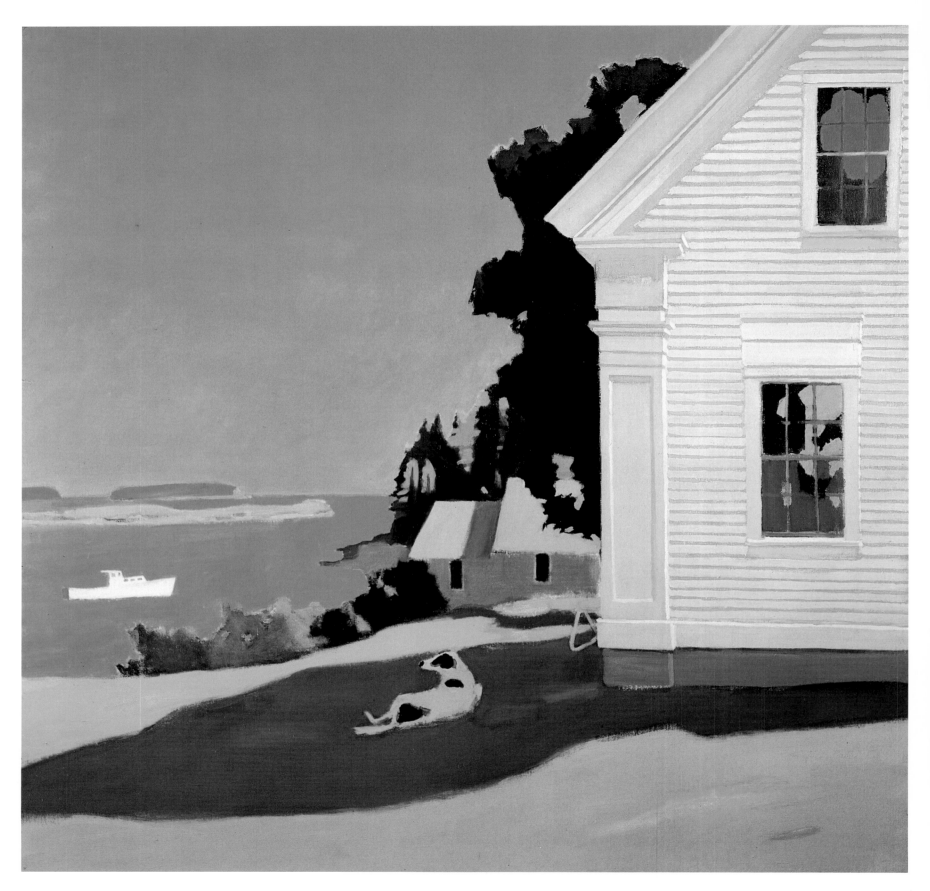

81. *Island Farmhouse,* 1969

beauty. And they're very accurate. They're done by the Coast and Geodetic Survey. And my father sometimes enlarged them, just making the island. And when he was enlarging them and writing titles his hands sort of trembled so they all kind of shake a little. But anyway, these maps are all done according to a system. They're done scientifically. The surveying is done according to a definite scientific system. And there it is. And then I saw after the war — my brother-in-law, who is in the government, got hold of some aerial photographs of the same place. An airplane flying above just took these islands from above. And I looked at them and I saw that the curves of the shore, the beaches, and so on and the different colors of the water and the streak of foam or tidal currents or something all had a relationship to each other. It was artistic and it was completely accidental. Whereas these things done according to a system by surveyors are completely chaotic. I mean in a very small way they're chaotic. They're chaotic in a large way, I mean you might say there's this and there's this and that balanced. But if you look at it in detail the details somehow don't have the sequential logic. But in the photograph they do. Well, that's one bit of evidence. In other words, nature, in that case the camera, is unconscious and it shows you that here is form. You never could have arrived at it; people cannot arrive at it deliberately and by using their intelligence. And another bit of evidence that I think of is I remember studying when I was in high school, doing algebra or something and it was very hard and making a doodle, you know, as one does when one is thinking and bored. And then I would see the doodle and I would like the way it looked. It had a certain spontaneity and freshness; it had a certain shape. And I would think I'll do it again, I'll copy that because I like it. I would copy it, but the copy didn't have that freshness. It was only chaotic.

PC: So it follows really a kind of feeling, an emotional expression rather than an intellectual choice?
FP: It comes from the unconscious. Once I was psychoanalyzed. And in psychoanalysis, of course, you follow your free associations without criticism. And what you get when you're all through (or you're never all through) is that you get yourself. This is your shape. And you get it by following — not by ordering the thing or using your head, but by being unconscious. And from psychoanalysis I got this idea: What you get is simply what you are. And what you are is not something that you can say — I am A, B, C, D, so and so, I have such and such complexes. That wouldn't be it. That would be a little bit off everywhere. What you are is simply what you've been saying all this time. Not any less than that. And not only that is what you are but you are somebody you know, whom other people recognize as you. And you say something and that is you, or it's characteristic. But if you think carefully, you are in danger of people saying he is not being direct, he's not being sincere, he's not being simple, it's not himself. That isn't he. In other words, what *is* the form is what is real and that is something that you can't get outside of, in psychoanalysis or in art.

PC: That's comprehensive. You have never tried to write your aesthetic theory?
FP: Yes, I have. Parts of it. One thing I wrote for *Art and Literature* was — I called it "Against Idealism." And I meant by that against the Platonic notion that what is real is an idea. That is *not* what is real. Plato is wrong. He's completely wrong. And that has nothing to do with art. What is real is not an idea, it is not that; it's specific and it's total, it's both specific and total. And once I said that at Kent State University. There I was on a panel with these other artists in which we also talked to philosophy students. That was what I

said to them: that Plato is completely wrong, that art is not ideal, it's material and specific and actual. It's not an idea.

PC: Do you think that painting is more of an emotional expression than an intellectual one?
FP: No, I don't think it's more emotional or more intellectual. I think it's a way of making the connection between yourself and everything. You connect yourself to everything that includes yourself by the process of painting. And the person who looks at it gets it vicariously. If you follow music you vicariously live the composer's efforts.

PC: Don't you think the person looking at a painting has an entirely different relationship to it than the person who's painted it?
FP: For one thing they see something that the person who's painted it hasn't seen — that's very hard for him to see. They are communicated with. They see the person who has painted it and his emotions, which he, maybe, doesn't see. When they say they don't like such and such an art, what they don't like is something that is really there. It isn't something that's imagined. I don't like Andrew Wyeth's paintings, for instance. It would be very hard for me to say why. I think the reason is that there's something he communicates to me that is disagreeable to me — something from him that I dislike. In him. You see the painter, you see the artist in the work. Ad Reinhardt. People see his paintings at a show, and it makes them very angry very often. Well, Ad Reinhardt was an infuriating man. And he got that into his paintings.

PC: But calculatedly so?
FP: Right. That's what was infuriating. That calculation.

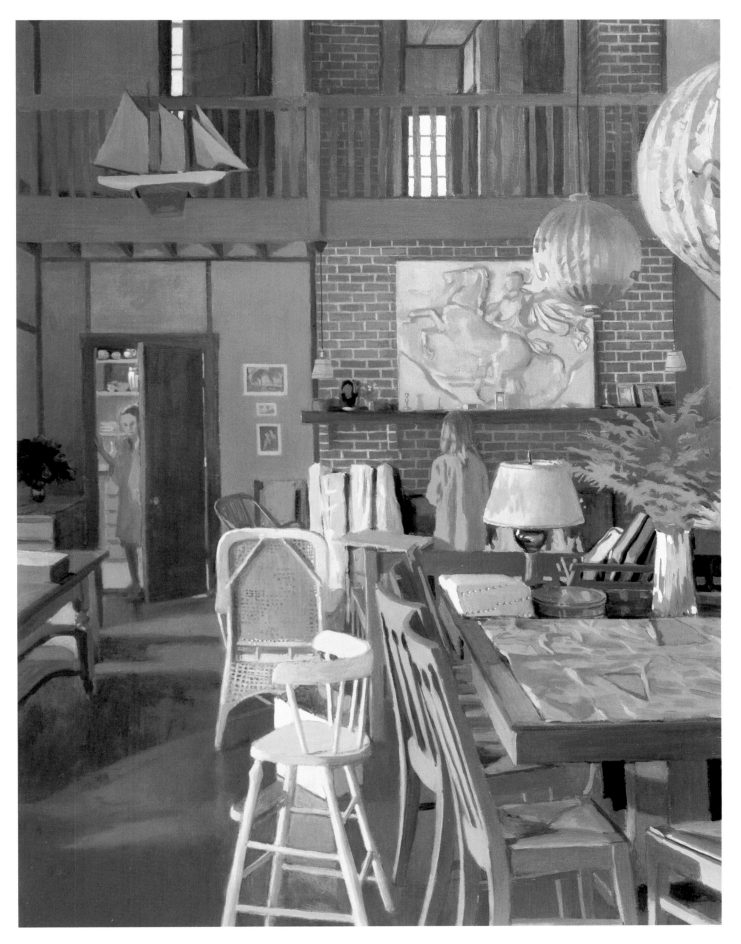

80. *Interior with a Dress Pattern,* 1969

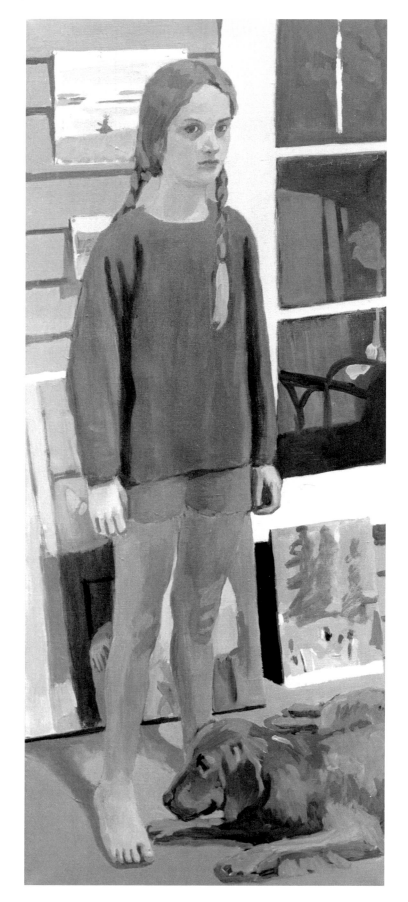

84. *Lizzie and Bruno,* 1970

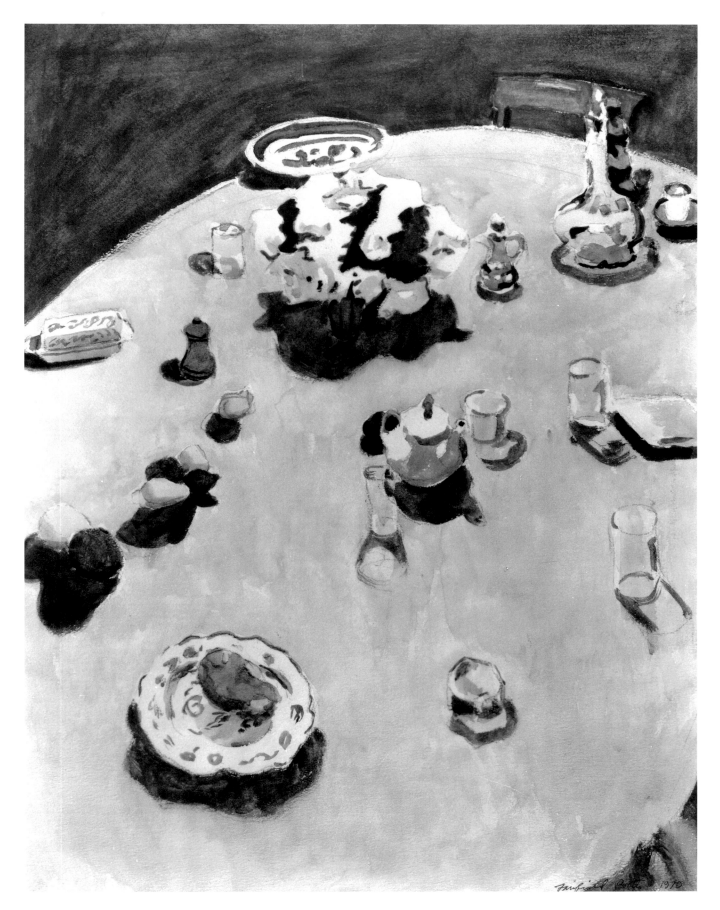

134. *The Table,* 1970

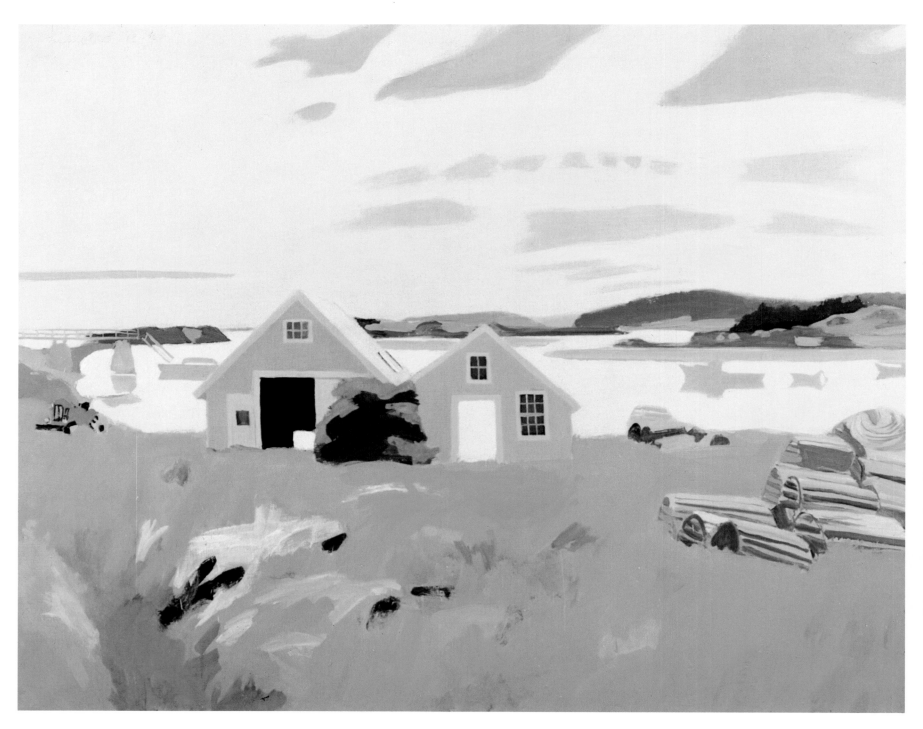

78. *Boathouses and Lobster Pots, 1968-1972*

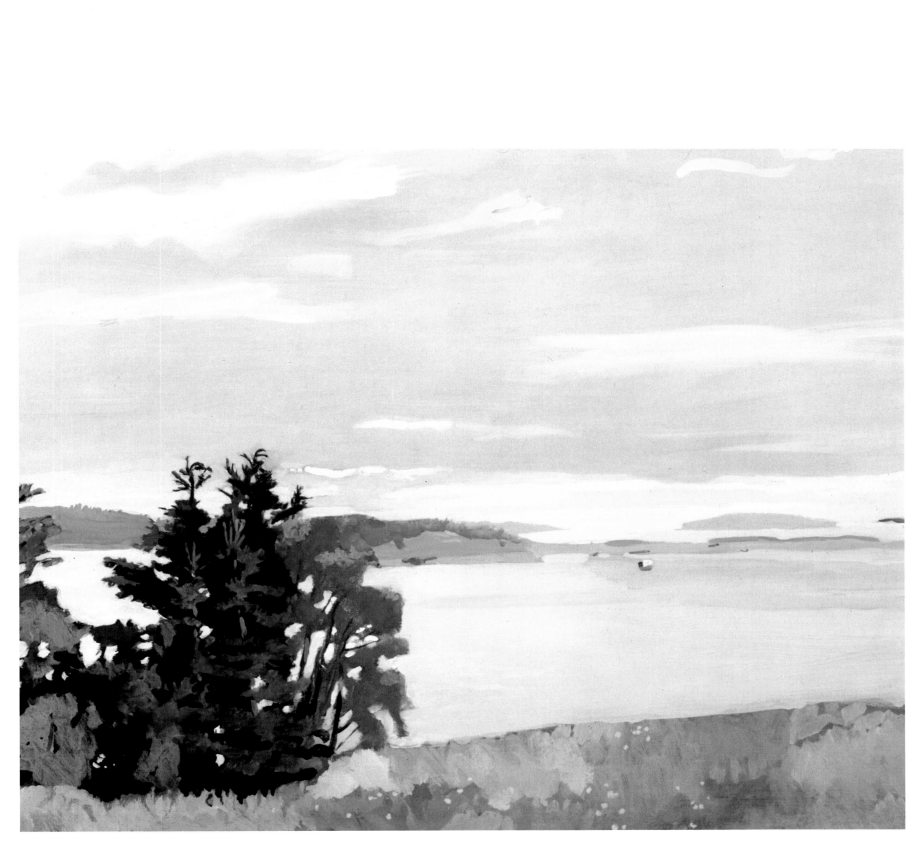

86. *View of the Barred Islands,* 1970

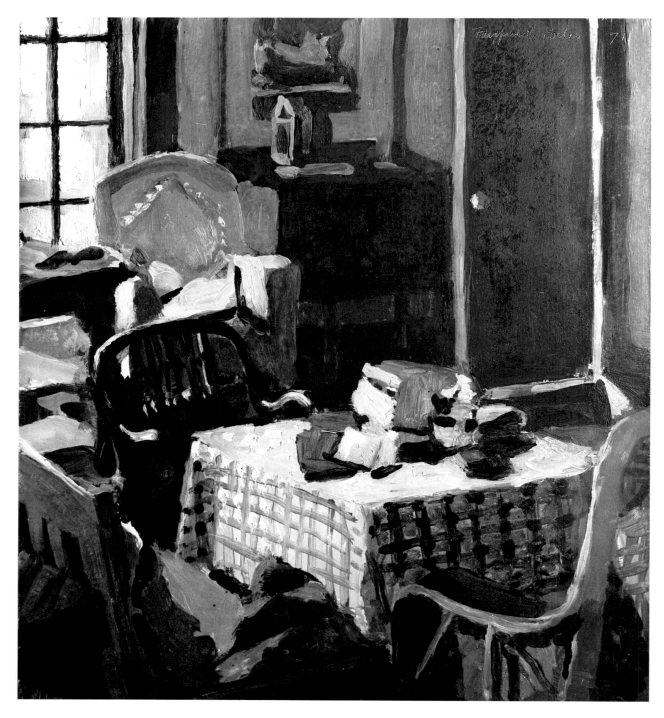

85. *Red and Brown Interior*, 1970

101. *Door to the Woods*, ca. 1972

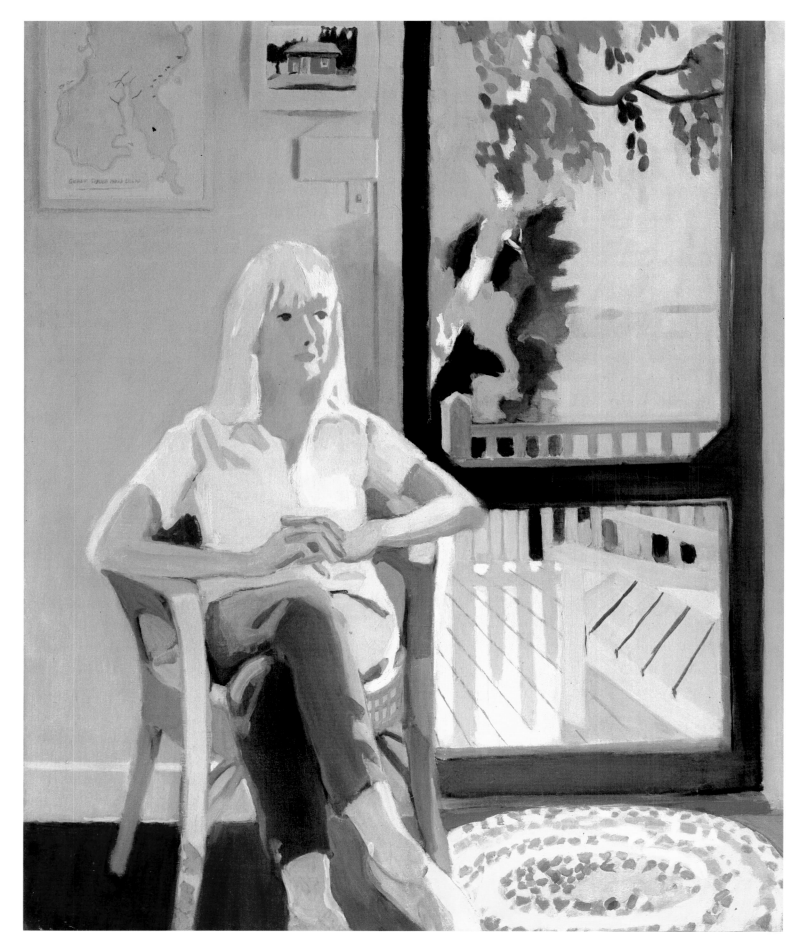

87. *Aline by the Screen Door,* 1971

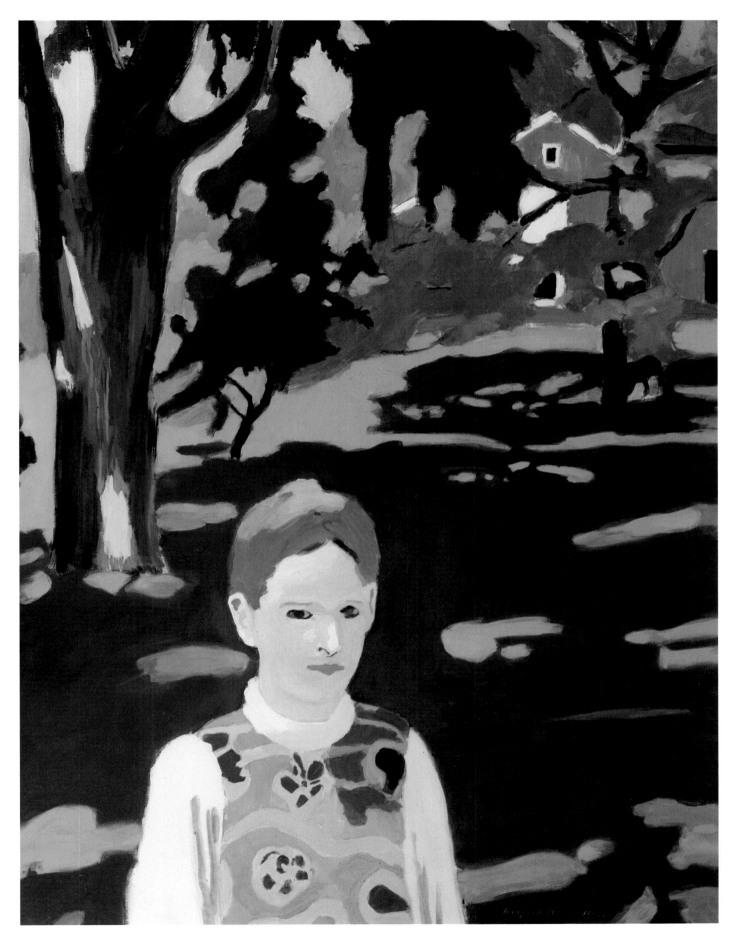

89. *Under the Elms,* 1971-1972

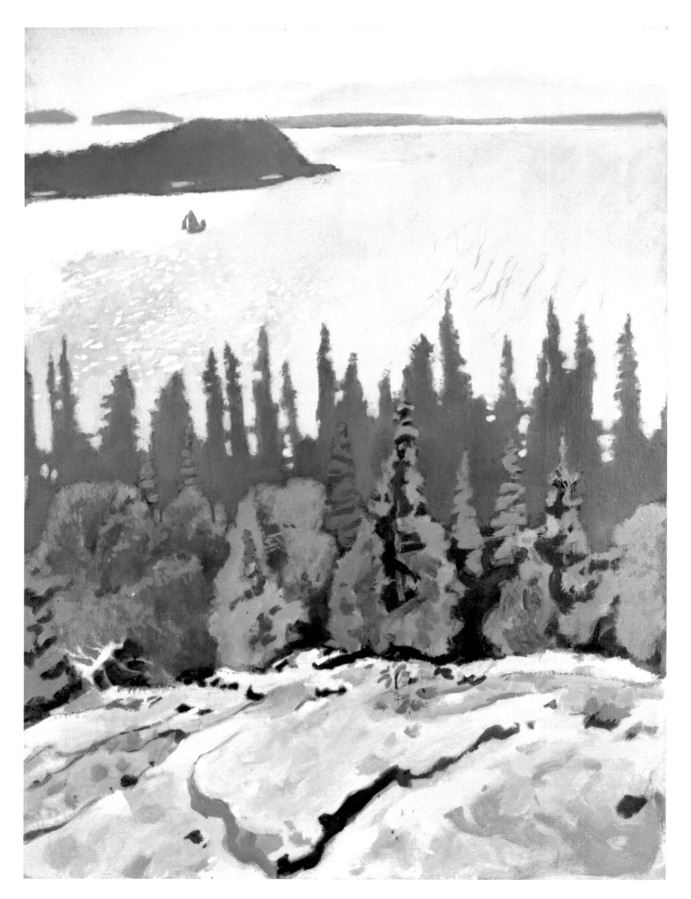

102. *View From a High Ledge, No. 2, 1972-1975*

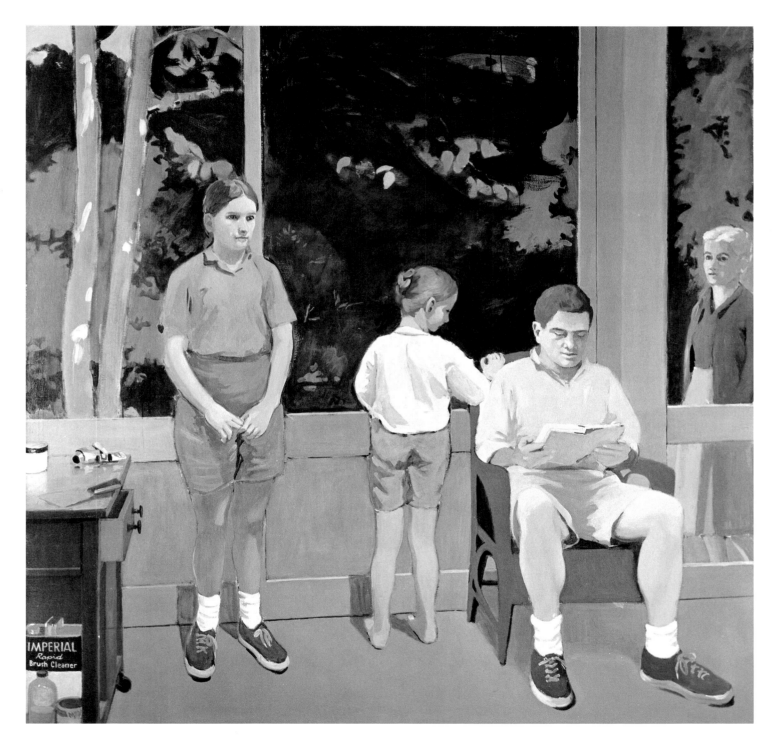

96. *The Screen Porch*, 1972

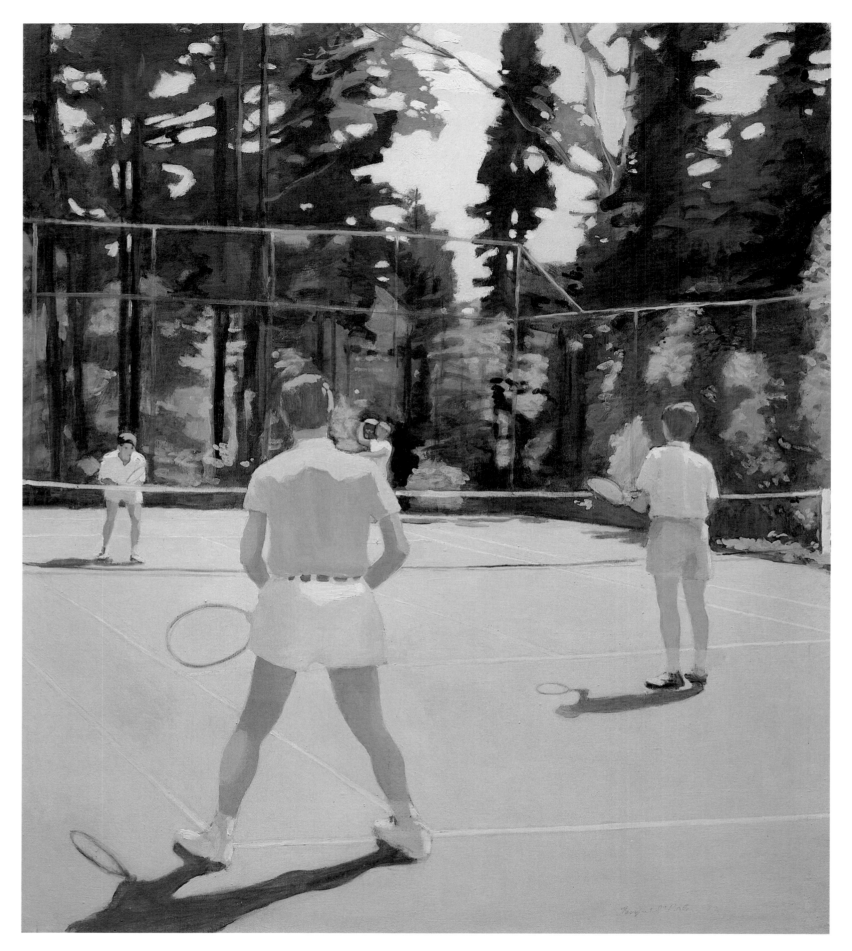

98. *The Tennis Game, 1972*

In the Blue Still Air*

The spruce pollen shaken from the trees
 At the tenderest stir
Moves in tall clouds before them
 To drift uselessly,
Salting the moss and leaves underfoot,
 And settle promiscuously
On the table and chairs and cement
 In mustard ripples.
The boys living in the next house
 Burst into giggles
At every careless observation,
 The food they cook
In vast quantities is quite inedible,
 Their faces look
As burned and tawny as the spruce flowers.
 The orchard blooms,
And the green meadows and the green woods
 Are uninhabited room
Decorated with different kinds of tiny flowers.
 An old farmer
On another island to which I row
 In his worn pasture
Tends a few cows and sheep and chickens
 At the top of the hill,

Though no one buys the eggs and milk,
 Or the sheep's wool.
His hair is white as the pasture flowers.
 "What will the weather be?"
I ask him, and he looks across the sun
 To the horizon of the sea
"There's never any telling," he replies.
 Next day from the north
A huge wind blows across the icy water
 And veers to the south,
Bringing the rain in black gusts
 For a whole day
Till the well overflows and torrents pour
 Into the bay.
I lay a huge blaze in the living room
 That is so hot
It turns the hearth into a furnace,
 But the heat is not
Great enough to warm me through.
 Like a boat under sail
The stove burns before the wind,
 And in the mail
I find only stale papers and stale bills.

— Fairfield Porter

*Fairfield Porter read widely in poetry all his life, having developed
early an appreciation of the work of the ancient Greeks, as well as
that of modernists such as Mallarmé and Hölderlin and Wallace
Stevens. Most of what he wrote himself came after he began
reviewing for *Art News* and met a number of poets. His collected
poems, with an introduction by John Ashbery, are being pub-
lished this year by the Tibor de Nagy Gallery.

Silence

Only time moves.
The bedspread dries on the furniture
A drip of moisture in the air
Cobwebs undisturbed
The arrangement of the bookcase
Past presences and present presences
For Katy reading:
Perhaps a creak in the joists
Perhaps the schooner becalmed on the balcony
Perhaps evaporation.
The wide door open to the afternoon
Reflected in the floor and fixed on the porch.
Ants penetrate the furry stems
A mink whistles in the rocks.
Only the sun moves
And the pages of the book she reads.

— Fairfield Porter

The Loved Son

When a loved son turns his back and goes
Down the street on a bicycle become too small
His overcoat flapping absurdly behind him
Maybe only as far as the beach

My heart is suddenly wrenched out of me
And I might as well let go and be done with it
And stay heartless, for what use could regret be
If my heart must no longer follow him?

When the grown boy turns his back and leaves
Looking forward to college or even to the army
Glad to be grown up, happy to be gone
Counting his new dependence as independence

I think how carelessly I have regarded him
With what little penetration I have known him
And have not listened to the pleasant wit
That marks the shrewdness of his watching mind.

In whatever new place for a short time his home
Surrounded by companions of his own age
Carrying with him no baggage of infancy
But the disappearing scars of his childish wounds

His new friends now, freshly for the first time
With contemporary easy intimacy
In a flash of insight looking in his eyes
Know the depths of his being and love him instantly.

— Fairfield Porter

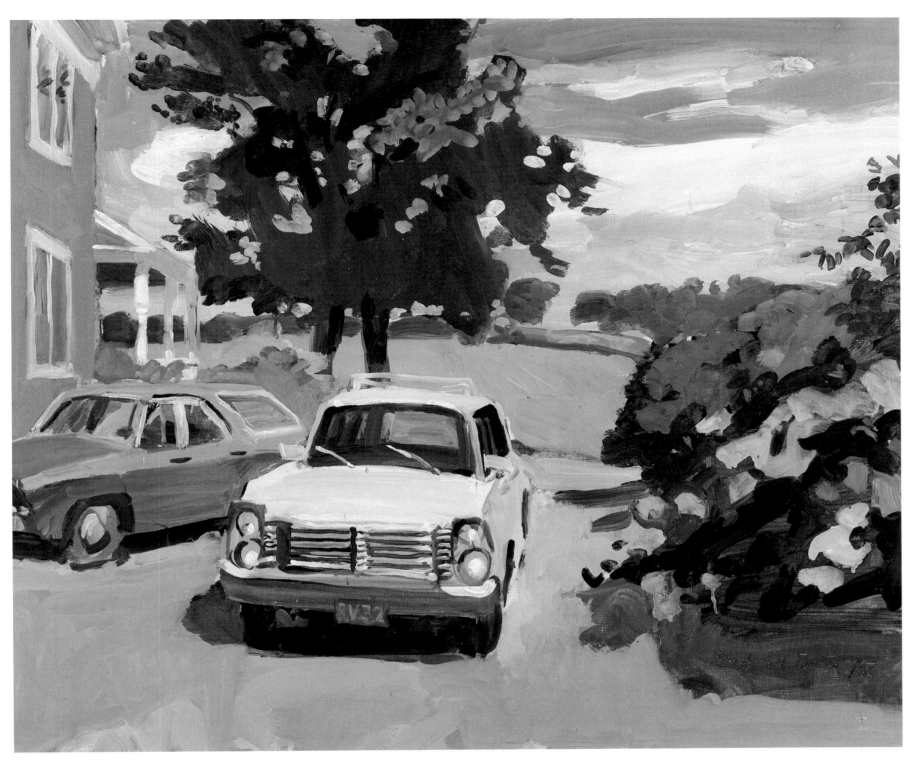

92. *Landscape with Two Parked Cars, 1972*

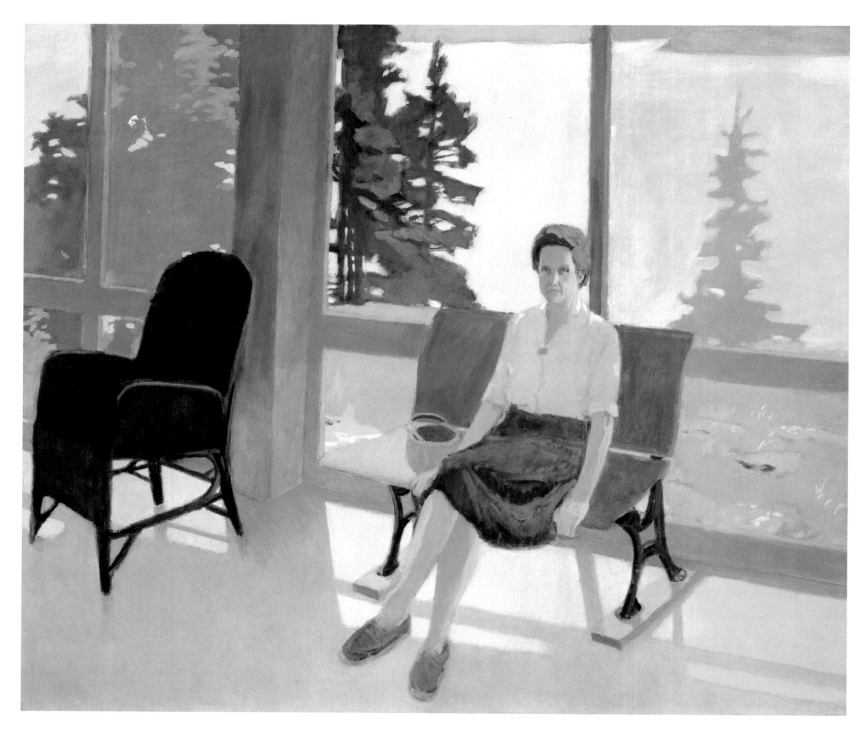

107. *Nancy Porter Straus, 1973*

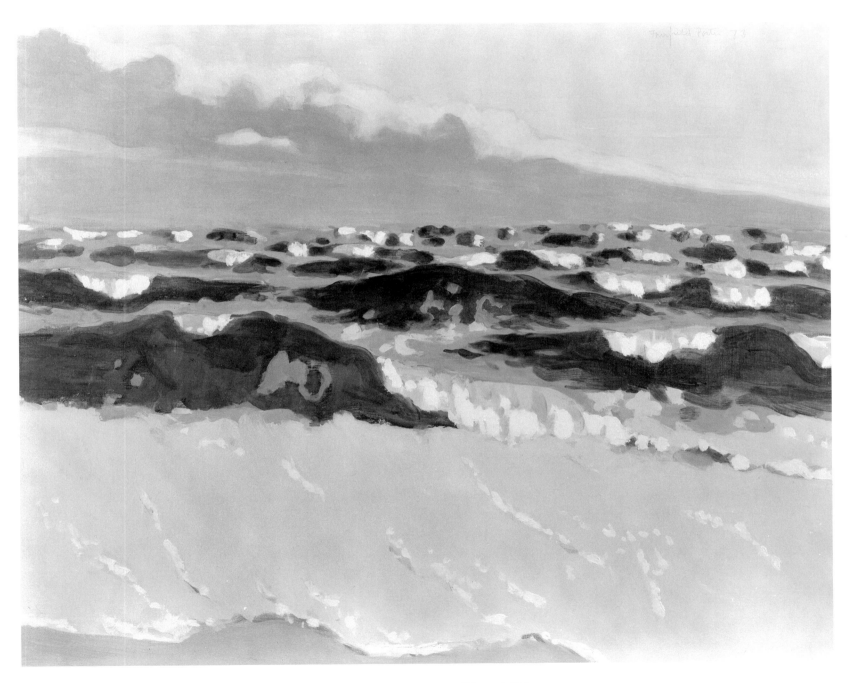

105. *A Sudden Change of Wind, 1973*

To the Mainland

Confused with sleep you leave the house and go
Through the morning grass before anyone is awake
And before the flowers sparkle in the risen sun,
To the slippery float covered with a slime of dew,
Where the fishing boat is tight on its dampened knots
In the black and yellow slick of low tide waiting.
The numbed rope is loosened and the boat with a roar
Starts a numb journey in the fresh morning,
Turning from the wakening barn and the wakening houses
Where boys dream of love on the throb of the engine
And old men forget where they are, lost in late sleep,
And a child calls for her mother frightened by a dream;
Past the black woods and the ocher meadows
Past a wave of recognition from the house on the cliff.
Then fixed on the glass of the sky-white water
Through which a fish hawk floating overhead
Sees sculpins in the mud and lobsters in the weed
And sea urchins like green burrs on the bright rocks
Of the quiet bottom deep under the propeller
Roaring above where the high early light is gray;
Where there is light without color, peeling paint
On the wet wood of the boat, and the rusty pipe
And coils of rope and the tender lashed on the stern
And bits of line and brass and the quivering compass
And white putty on the windows looking forward:
The noise so deafens you can hardly talk
You and your companion, together and apart,
But only look out on the water or at the compass
Following a way that it knows without knowing.

— Fairfield Porter

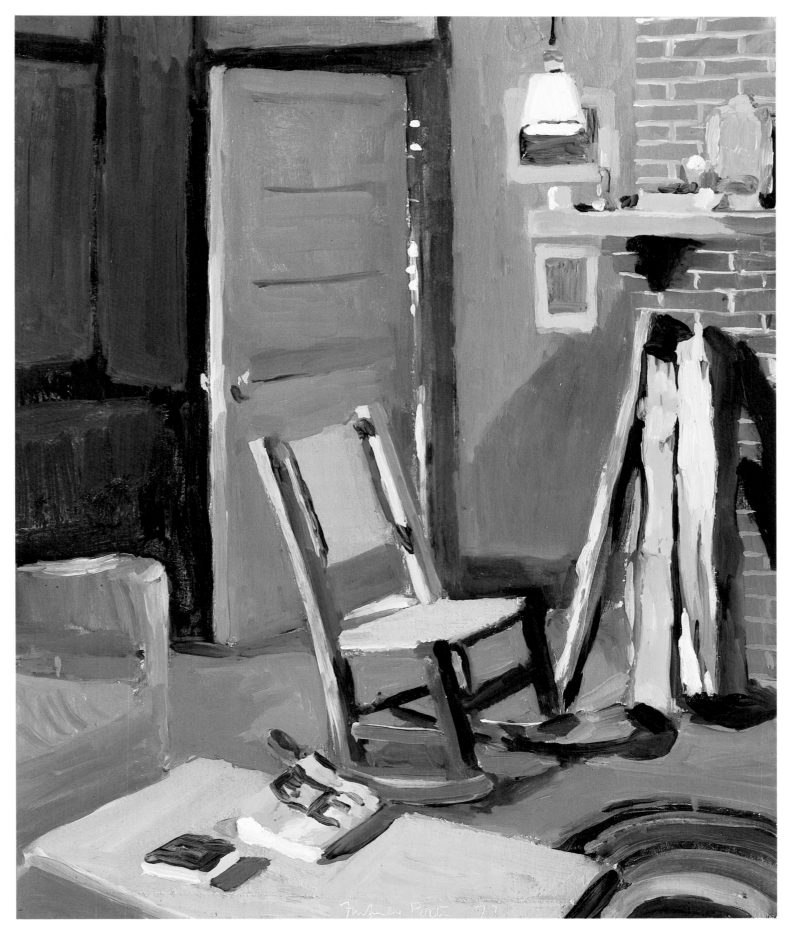

106. *Logs and Rocking Chair,* 1973

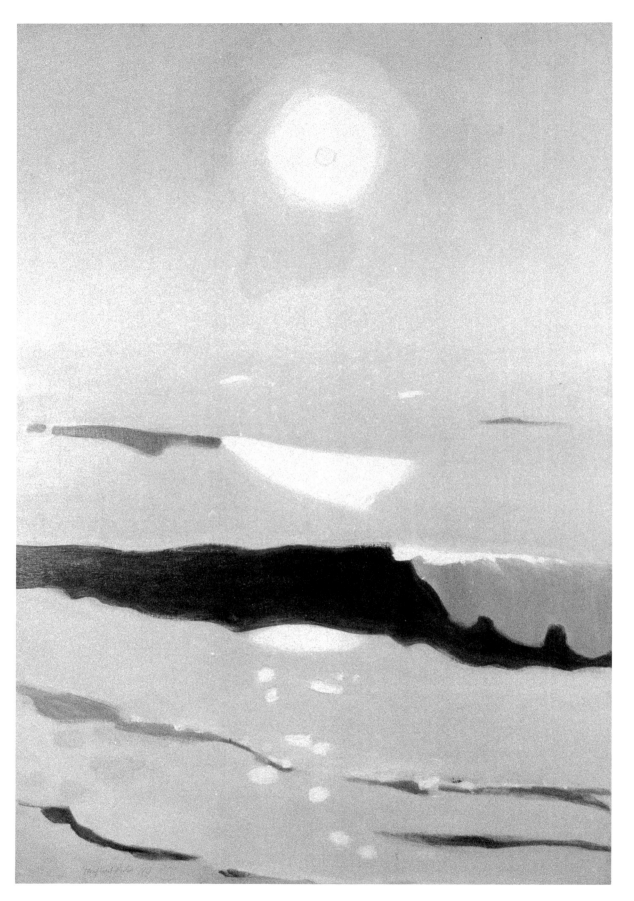

104. *Sun Rising out of the Mist, 1973*

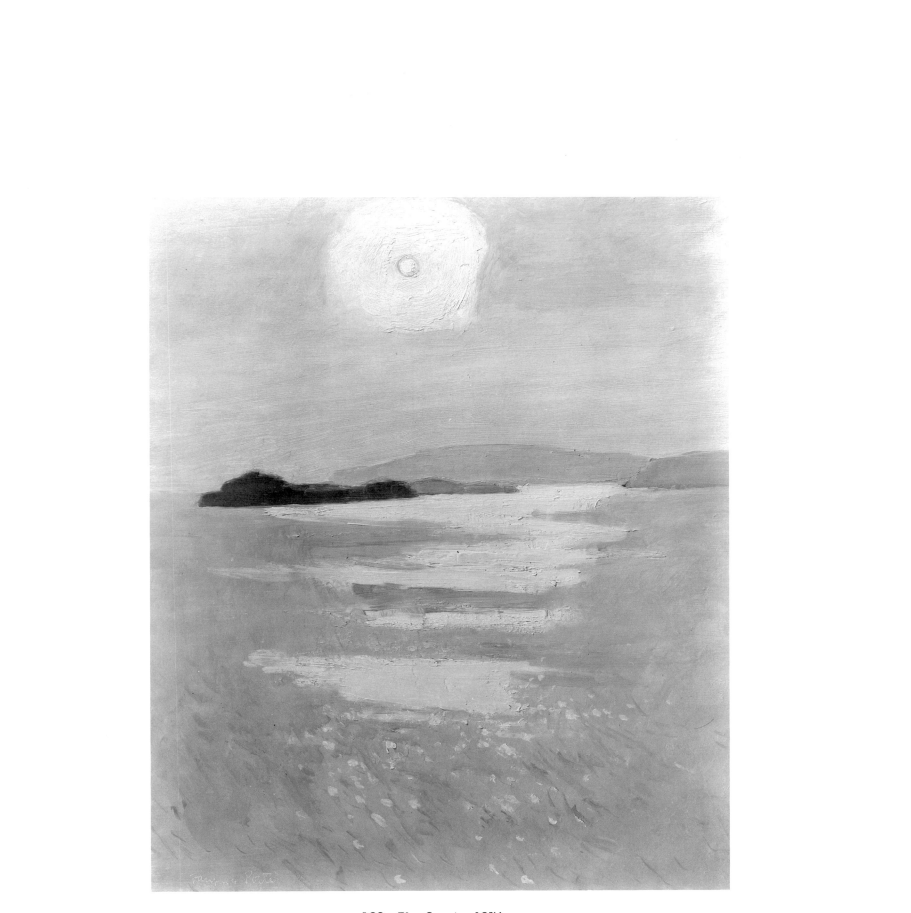

109. *Blue Sunrise,* 1974

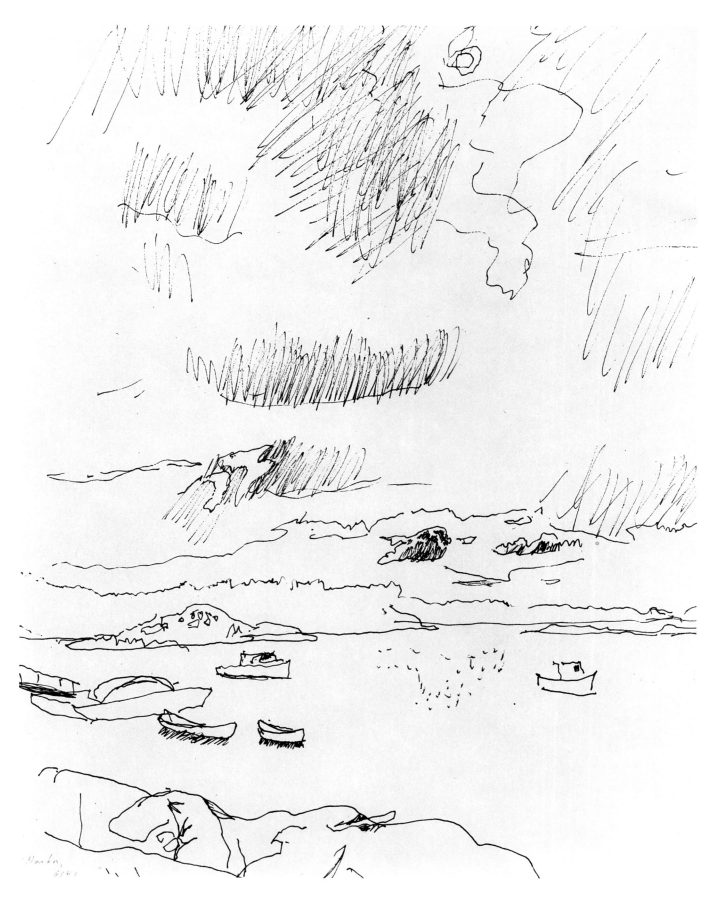

139. *The Harbor — Great Spruce Head Island, ca. 1974*

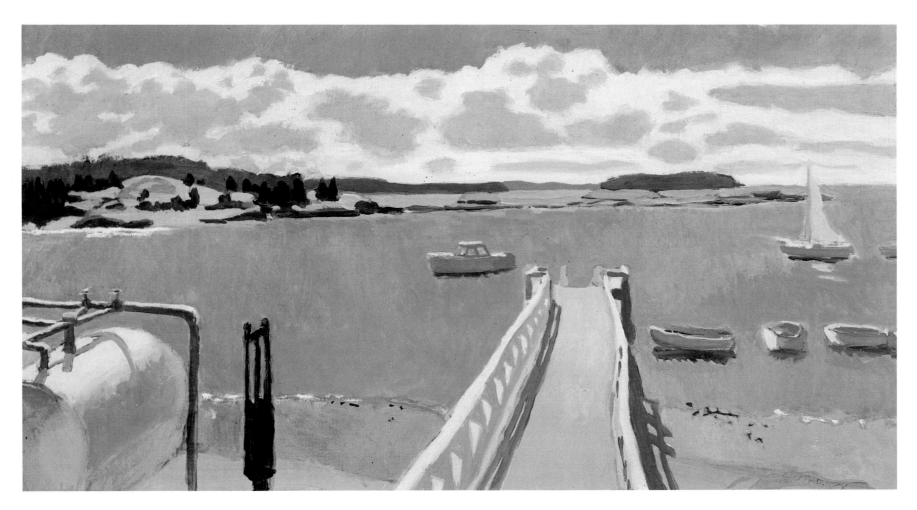

116. *The Harbor — Great Spruce Head,* 1974

133. *Cooper Square, 1968*

119. *Broadway South of Union Square, 1975*

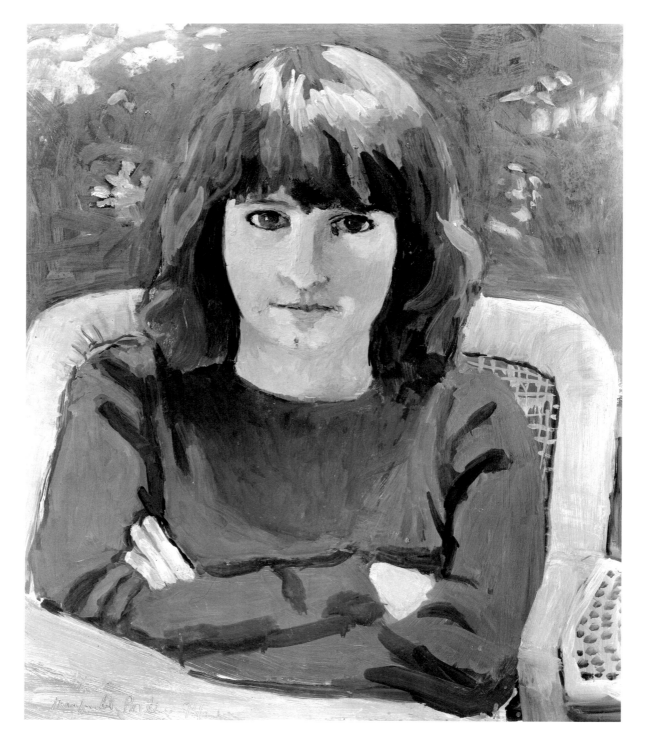

111. *Katie*, 1974

112. *Monument Mountain*, 1974

A Painter Obsessed by Blue

No color isolates itself like blue.
If the lamp's blue shadow equals the yellow
Shadow of the sky, in what way is one
Different from the other? Was he on the verge of a discovery
When he fell into a tulip's bottomless red?
Who is the mysterious and difficult adversary?

If he were clever enough for the adversary
He should not have to substitute for the blue,
For a blue flower radiates as only red
Does, and red is bottomless like blue. Who loves yellow
Will certainly make in his life some discovery
Say about the color of the sky, or another one.

That the last color is the difficult one
Proves the subtlety of the adversary.
Will he ever make the difficult discovery
Of how to gain the confidence of blue?
Blue is for children; so is the last yellow
Between the twigs at evening, with more poignancy than red.

A furnace with a roar consumes the red
Silk shade of a lamp whose light is not one
Like birds' wings or valentines or yellow,
Able to blot out the mysterious adversary
Resisted only by a certain blue
Illusively resisting all discovery.

Did it have the force of a discovery
To see across the ice a happy red
Grown strong in heart beside intensest blue?
In this case the blue was the right one,
As a valentine excludes the adversary,
That will return again disguised in yellow.

If it were possible to count on yellow
Dandelions would constitute discovery:
But all at once the sudden adversary
Like a nightmare swallows up the red,
To dissipate before the starry one,
The undefended wall of blue.

Blue walls crumple under trumpets of yellow
Flowers — one unrepeatable discovery —
And red prevails against the adversary.

— Fairfield Porter

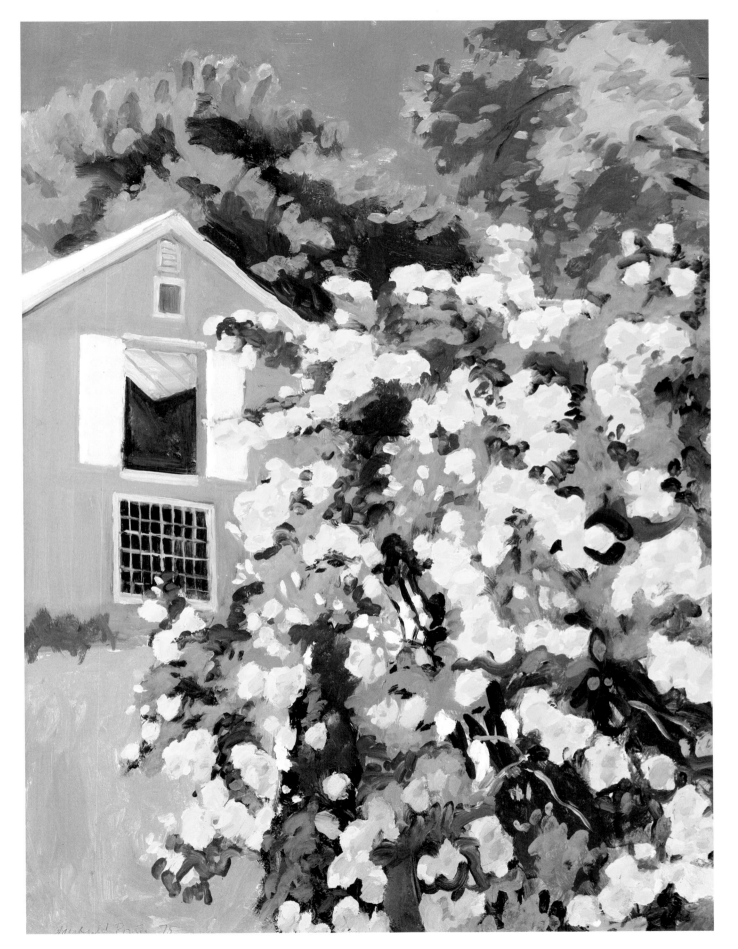

120. *Persian Rose Bush*, 1975

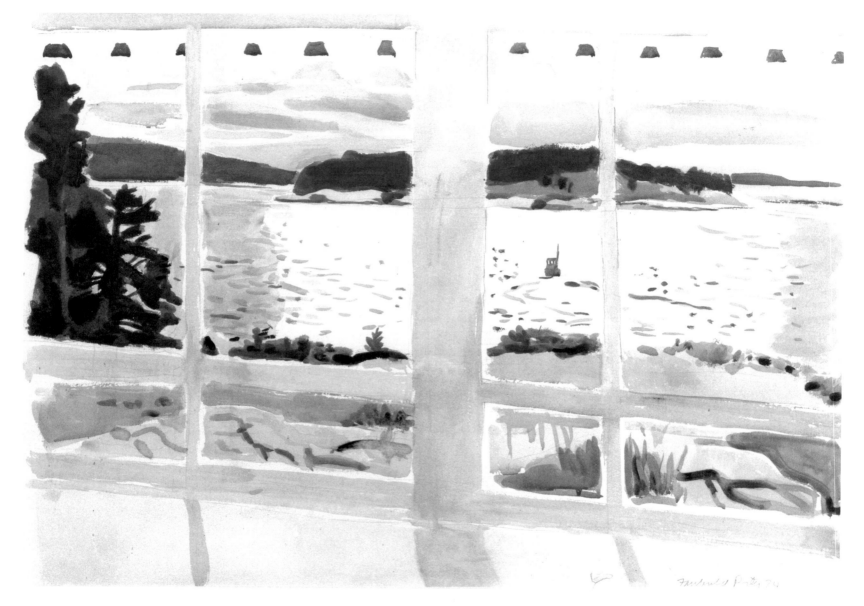

136. *Morning From the Porch*, 1974

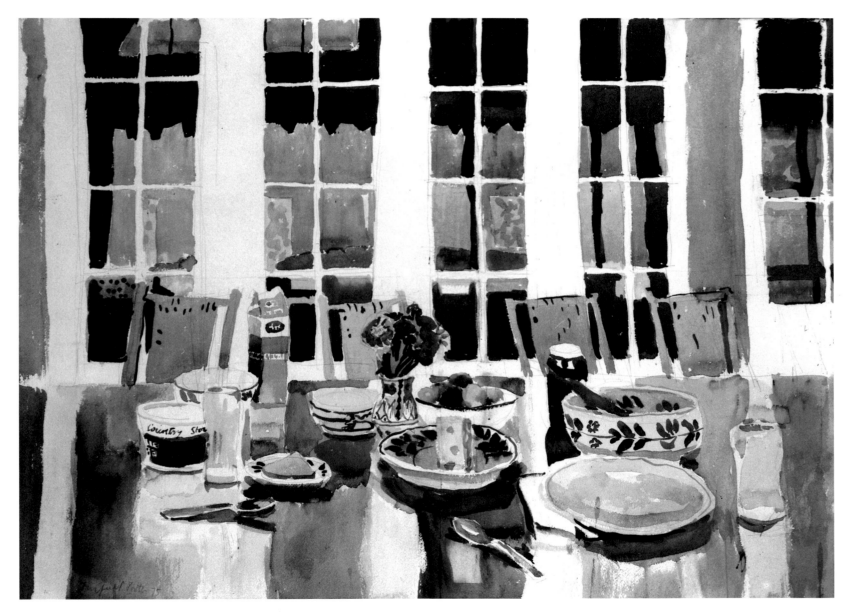

140. *Still Life*, 1975

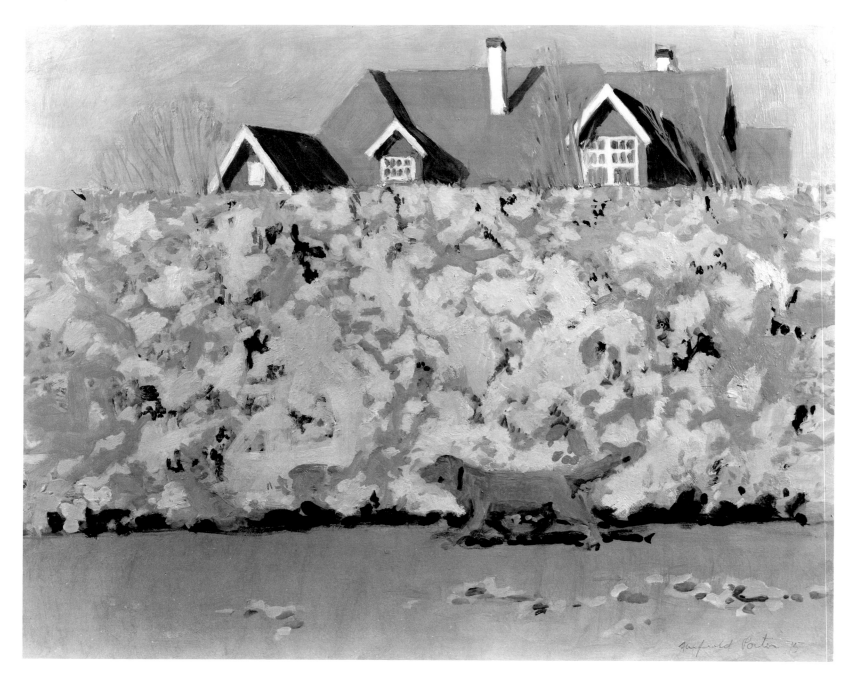

124. *The Privet Hedge,* 1975

* *

Chronology

Compiled by Prescott D. Schutz

Hirschl & Adler Galleries, New York

1907

Born on June 10 at Hubbard Woods, Winnetka, Illinois, the fourth of five children. Father was James Porter, born in Racine, Wisconsin, and mother was Ruth Furness Porter, of Chicago. His father was an architect of private means and through him the children acquired a wide-ranging interest in the sciences and architecture. From their mother the children acquired a taste and aptitude for writing and the arts. The family set a high value on knowledge, freedom, and duty.

1912

James Porter purchased Great Spruce Head Island in Penobscot Bay, Maine. There he designed and built a farmhouse and, about ten years later, a large cottage and barn. The former was in the Greek-revival style of village houses in that part of Maine (particularly in Searsport), the latter a commodious cottage very much in the style of the period. The exterior and interior spaces of the cottage were handled, within the convention, in most original ways; the living room — the scene and subject of many of Fairfield Porter's paintings — was two stories high with balconies at either end, off which are bedroom corridors. Beyond the windows are open porches, creating a soft and infinitely variable light. It was here, as a child, that he first experimented in *plein-air* sketching in pastels and watercolors.

1913

Spent the first summer on Great Spruce Head Island, as he did nearly every summer of his life.

1919

Traveled to Canada with his family shortly after the end of World War I.

1921

At age 14, traveled to Europe with his family and saw paintings by Leonardo da Vinci, Titian, Veronese, and Turner.

1923

Graduated from New Trier Township High School, later to become one of the finest high schools in the country, at age 16. His parents thought him too young to enter college, so he spent part of the following year at Milton Academy in Milton, Massachusetts.

1924

Entered Harvard College, from which he graduated with a Bachelor of Science degree in Fine Art. Among the courses he particularly valued were those in fine arts taught by Arthur Pope and Kingsley Porter, in history (William Langer), and, perhaps most significant, in philosophy (Alfred North Whitehead).

1927

During junior year at Harvard, contributed an illustration to *Harvard Lampoon*. Spent summer in Europe for the first time on his own; during a walking tour in France the cathedral in Coutance made an especially vivid and lasting impression. Later that summer he flew from Berlin to Moscow, a flight of 1,500 miles at the speed of 100 miles per hour. The few weeks he spent there affected his attitude and activities during the Depression toward Marxism, Leninism, Trotskyism, and Stalinism, though Porter said: "I did not become an active Socialist: I was the least of dilettantes." This sincere change in attitude was part of an evolving one that, in his maturity, might have been described as one of assessing issues individually and arriving at political and active social decisions as objectively as he found possible. While in Russia he was present at an interview given by Trotsky and was able to sketch him. An essential influence on Porter's thought and life and, therefore, his art were the works of Dostoyevsky, Chekhov, and Tolstoy, in particular *War and Peace*. His memory of his visit to Moscow was particularly vivid. While there he saw the Shchukin Collection of Modern Art.

1928

Graduated from Harvard and moved to New York, where he lived in a 15th Street rooming house.

Attended the Art Students League for two years, working in life classes with Thomas Hart Benton and Boardman Robinson.

In New York he met and became a friend of Arthur Schwab, who owned paintings by such artists as John Marin, Oscar Bluemner, Yasuo Kuniyoshi, Arthur Dove, etc. Porter was subsequently much influenced by Marin's paintings. It was at this time that he met Alfred Stieglitz.

1931

In September, traveled for a month in Italy, finally settling in Florence until January of 1932. Spent much time copying in the Uffizi and the Pitti. Of note were Pesellino's predella of the martyrdom of Saints Cosimo and Damiano in the Uffizi and Raphael's *Donna Gravida* in the Pitti. Among acquaintances were those made with Umberto Morra and Bernard Berenson, who particularly recommended to Porter the Pontormo frescoes at the Villa Medici.

1932

In January, visited Berlin, Munich, and Dresden, where a friend was a student of Mary Wigman. Of Wigman he once said (having seen her perform in New York in 1933), "I've never been so thrilled by dancing"

February and March were spent in Rome, where he made his first lithograph ("It was awful"), an illustration for *The Possessed* by Dostoyevsky. In the spring he flew from Genoa to Barcelona, visited Madrid — the Prado and the Escorial — and returned to America by way of Paris and London. It was his last visit to Europe until 1967. He settled in New York and in September married Anne Channing from Boston. They had five children: John, born 1934; Lawrence, 1936; Jeremy, 1941; Katharine, 1949; and Eliza-

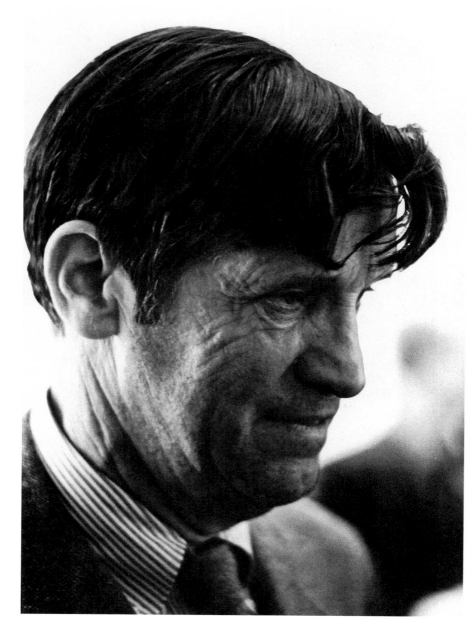

Fairfield Porter
at a Gotham Book Mart publication party in the 1960s.

beth, 1956. He studied anatomy, dissecting cadavers at Cornell University School of Medicine.

1933
Member and teacher at Rebel Arts, a Socialist art group.

1935
Contributed to *Arise,* a short-lived Socialist magazine, published in opposition to *The New Masses.* To it he contributed his first critical article — a catalogue of socially conscious mural paintings to be found in New York City at that time.

Lived in Croton-on-Hudson, New York, and in New York City, working independently in a studio off Union Square.

1936
Met the poet John Wheelwright, and made lino-cuts for the series "Poems for a Dime." Both were editors of *Arise* and "Poems for 2 Bits."

Moved back to Hubbard Woods when his grandmother died; lived in her house next to his parents.

Met Paul Mattick and Fritz Henssler, both communists, by whom he was greatly influenced. Through Mattick he met the photographers Ellen and Walter Auerbach and, through them, Edwin Denby, Rudi Burckhardt, Elaine (Fried) and Willem de Kooning. Among painters of this century, de Kooning and Vuillard became the primary influences on his work. In about 1934 he bought the first of several de Koonings, thus becoming one of the first to own major paintings by that artist.

1938
Saw exhibition of Vuillard and Bonnard at Chicago Art Institute. Became member of Chicago Society of Artists.

1939
Moved to Peekskill, New York, where he lived in three different houses in successive years.

Father, James Porter, died.

Met Clement Greenberg.

First one-man exhibition at North Shore Art Center, Winnetka, Illinois. Group exhibitions at Art Institute of Chicago, Pennsylvania Academy (Philadelphia), and Artists' Union, Chicago.

1942
Moved to New York, where, with an inheritance, he bought a house on East 52nd Street and lived there for the next seven years. To increase his income, studied mechanical drawing at the Delehanty Institute. That fall he became a draftsman at the firm of Walter Dorwin Teague, doing classified work for the Navy, principally illustrations for a catalogue of gun mounts. ("The day after VJ Day — I quit.") During the war he began taking night classes at Parsons School of Design with Jacques Maroger, former art restorer at the Louvre in Paris and the discoverer or re-inventor of the "lost" Flemish and Venetian mediums. Since that time, except

for a short period using acrylics in the early 1960s, Porter used mainly this paint. The medium could be bought ready made, but he preferred to prepare his own, an exacting process.

1949
Moved to Southampton, New York, where a barn at the back of the property became his studio. There in Long Island and in Great Spruce Head in Maine, Porter was to paint the great majority of his paintings.

1950s
Met poets Frank O'Hara, James Schuyler, John Ashbery, and Kenneth Koch. Other close friends included painters Alex Katz, Robert Dash, Jane Freilicher, Neil Welliver, Jane Wilson, and Paul Georges.

1951
Elaine de Kooning recommended Porter to Thomas Hess, editor of *Art News,* who took him as associate editor. Porter there wrote reviews and articles primarily about contemporary art. He had his first one-man exhibition in New York at Tibor de Nagy Gallery, of which John Bernard Myers was the director. This brought him in close association with a group that included Jane Freilicher, Larry Rivers, Grace Hartigan, and Alfred Leslie.

1951
From this year to 1970, Porter had 15 exhibitions in New York.

1959
From this year to 1968, Porter exhibited in six Whitney Annuals. He also wrote art criticism for *The Nation.* He received the Longview Award for contributions to art criticism for an article on Willem de Kooning.

One-man exhibition at Rhode Island School of Design, Providence. Monograph on Thomas Eakins, published by George Braziller, New York. Also an article on Richard Stankiewicz for *The New York School, Some Younger Artists.*

1960-61
Produced a group of lithographs by a new paper-offset-plate model. During this period he was also a frequent contributor to *The Nation, Art in America,* and *Evergreen Review.*

1963
One-man exhibition at University of Alabama, Tuscaloosa.

1964
Visiting artist, Skowhegan School of Painting and Sculpture in Maine.

1965
One-man exhibition at Reed College, Portland, Oregon.

1966
Retrospective at Cleveland Museum of Art. Taught painting and

lectured at Southampton College, as he did over the years at Yale University, Skowhegan School of Painting and Sculpture, and Maryland Institute of Fine Arts, which he visited annually.

1967
One-man exhibitions at Trinity College in Hartford, Kent State University in Ohio, and Swarthmore College in Pennsylvania.

1968
Exhibited at United States Pavilion, Venice Biennale.
Lectured at Queens College, New York.

1969
Artist-in-residence at Amherst College.
Exhibited in "Photographs by Eliot Porter, Paintings by Fairfield Porter," Colby College, Waterville, Maine. Catalogue with essay by James Carpenter.
Received honorary degree with brother Eliot from Colby College.
One-man exhibition at Gross-McCleaf Gallery, Philadelphia.

1970
Illustrated poem by Ted Berrigan. Received honorary degree from Maryland Institute, Baltimore.
Received prize from National Academy of Design, New York.

1971
One-man exhibition at Parrish Art Museum, Southampton, New York. Completed five color lithographs.

1972
One-man exhibitions at Hirschl & Adler Galleries in New York and Maryland Institute College of Art in Baltimore. Completed two color lithographs.

1973
One-man exhibition at Harbor Gallery, Cold Spring Harbor, New York. Included in group exhibitions at Randolph-Macon Woman's College in Lynchburg, Virginia, Dayton Art Institute in Ohio, and Harcus-Krakow Gallery in Boston.

1974
Visiting artist at Skowhegan School of Painting and Sculpture.
One-man exhibition at Hirschl & Adler Galleries, New York.
Included in group exhibitions at Cleveland Museum of Art, Kala-

mazoo Institute of Arts in Michigan, and Country Art Gallery, Locust Valley, New York.
Retrospective exhibition at Heckscher Museum, Huntington, New York.
Completed three color lithographs.

1975
One-man exhibition at the University of Connecticut, Storrs.
Included in group exhibitions at Carlton Gallery and Ingber Gallery in New York.
Completed two color lithographs.
Died on September 18, at age 68, in Southampton, New York.
One-man exhibition of watercolors at Brooke Alexander Gallery, New York.

1976
One-man exhibition at Hirschl & Adler Galleries, New York.
Included in group exhibitions at Corcoran Gallery of Art, Washington, D.C. ("America 1976") and Artist's Choice Museum, New York.

1977
One-man exhibitions at Parrish Art Museum, Southampton, New York; Colby College Art Musum, Waterville, Maine; Alpha Gallery, Boston; Harbor Gallery, Cold Spring Harbor, New York.

1978
One-man exhibition at Esther Robles Gallery in Los Angeles and Gross-McCleaf Gallery in Philadelphia.

1979
One-man exhibitions at Hirschl & Adler Galleries, New York; Barridoff Galleries, Portland, Maine; Gross-McCleaf Gallery, Philadelphia; Hull Gallery, Washington, D.C.; Artist's Choice Museum, New York; Mickelson Gallery, Washington, D.C.

1980
Included in group exhibitions at Parrish Art Museum, Southampton, New York; Chrysler Museum, Norfolk, Virginia; Suzanne Hilberry Gallery, Birmingham, Michigan.

1981
Included in group exhibition at Pennsylvania Academy of the Fine Arts, Philadelphia ("Contemporary Realism"; circulating exhibition).

Bibliography

Compiled by Rackstraw Downes
assisted by Louise Hamlin

Part I is intended to be as complete a list as possible of the writings by Porter that have been made public. Part II is a general list with a focus on critical reaction to Porter's work; it is intended as a reasonably comprehensive selection.

I. Writings by Fairfield Porter

Books

Thomas Eakins. Great American Artists Series (New York: George Braziller, 1959).

Fairfield Porter. Art In Its Own Terms. Selected Criticism, 1935 - 1975. Edited and with an introduction by Rackstraw Downes (New York: Taplinger Publishing Co., 1979). [This collection of Porter's critical writing contains otherwise unpublished material.]

Essays, Columns, Reviews, Statements

"Murals for Workers," *Arise* 1, no. 4 (1935).

Letter to the editor: "The Case of Leon Trotsky — Opinions Differ on the Truth of the Charges Against Him," *New York Times,* April 13, 1937.

Letter to the editor on the art criticism of George L.K. Morris and Clement Greenberg, *Partisan Review,* January - February 1941.

Letter to the editor on Wyndham Lewis's criticism of Picasso, *Kenyon Review,* September 1941.

"Reviews and Previews," *Art News,* November 1951 through September 1959. (To each of the ten issues of *Art News* published per year during this period, Porter contributed, on the average, twelve short reviews of current exhibitions in New York galleries. Though the quality of the writing in these reviews is very high, a detailed listing of them would be unwieldy in this context.)

"Evergood Paints a Picture," *Art News,* January 1952.

"Vasilieff Paints a Picture," *Art News,* October 1952.

"Hartl Paints a Picture," *Art News,* April 1953.

"Tworkov Paints a Picture," *Art News,* May 1953.

"Transatlantic Watercolors," *Art News,* June 1953.

"Rivers Paints a Picture," *Art News,* January 1954.

"The Nature of John Marin," *Art News,* March 1955.

"Herman Rose Paints a Picture," *Art News,* May 1955.

"Stankiewicz Makes a Sculpture," *Art News,* September 1955.

Letter to the editor on Clement Greenberg's definition of "American-type" painting, *Partisan Review* 22, no. 4 (1955).

"Sargent: An American Problem," *Art News,* January 1956.

"Meeting Ground at the Whitney," *Art News,* May 1956.

"Jane Freilicher Paints a Picture," *Art News,* September 1956.

"The Renaissance Cuisine," *Art News,* December 1956.

"George Bellows: Journalists' Artist," *Art News,* February 1957.

"David Smith: Steel into Sculpture," *Art News,* September 1957.

"From Inner Space," *Art News,* September 1957. [Review of *Architecture as Space* by Bruno Zevi.]

"American Painters in Words," *Art News,* May 1958. [Review of *Arshile Gorky* by Ethel Schwabacher, *Karl Knaths* by Paul Mocsanyi, and *The Shape of Content* by Ben Shahn.]

"The Short Review," *It Is,* Autumn 1958.

"Homer: American vs. Artist: A Problem in Identities," *Art News,* December 1958.

"Art, *Nation,* June 6, 1959 [de Kooning].

"Art," *Nation,* July 4, 1959 [restoration of Metropolitan Museum's El Greco].

"Art," *Nation,* October 3, 1959 [American abstract painting].

"Art," *Nation,* October 17, 1959 ['New Images of Man' exhibition].

"Art," *Nation,* October 24, 1959 [Happenings].

"Art," *Nation,* November 21, 1959 [American abstract sculpture].

"Art," *Nation,* November 28, 1959 [Cézanne].

"Art," *Nation,* December 19, 1959 [representational painting in New York and California].

"Art as a History of Drawing," *Art News,* December 1959. [Review of *Great Draughtsmen from Pisanello to Picasso* by Jacob Rosenberg.]

"Art," *Nation,* January 9, 1960 [Eliot Porter].

"Art," *Nation,* January 23, 1960 [Bischoff, Goodnough].

"Art," *Nation,* February 6, 1960 [Giacometti].

"Art," *Nation,* February 13, 1960 [Remenick, Grooms, Button].

"Art," *Nation,* March 12, 1960 [Mondrian, Arp, David Smith].

"Art," *Nation,* March 19, 1960 [Engman, Johns, Freilicher, Georges].

"Art," *Nation,* April 2, 1960 [Impressionism and contemporary colorists].

"Art," *Nation,* April 23, 1960 [Rembrandt, Degas, Stankiewicz, Rauschenberg].

"Art," *Nation,* April 30, 1960 [William King].

"Art," *Nation,* May 21, 1960 [Isabel Bishop].

"Art," *Nation,* May 28, 1960 [Constructivism].

"Art," *Nation,* June 18, 1960 [Photography].

"Art," *Nation,* September 10, 1960 [criticizing, exhibiting, restoring art].

"Art," *Nation,* October 1, 1960 [Young Americans at the Whitney Museum].

"Art," *Nation,* October 15, 1960 [Assemblage].

"John Graham: The Painter as Aristocrat," *Art News,* October 1960.

"Art," *Nation,* November 5, 1960 [Twombly, Reinhardt, Fiore].

"Art," *Nation,* November 26, 1960 [Guggenheim International Award Exhibition].

"Art," *Nation,* December 3, 1960 [Whistler, Morisot, Corinth].

"Art," *Nation,* December 24, 1960 [Nakian, Agostini].

"Art For Morality's Sake," (book review of *The Insiders* by Selden Rodman), *Nation,* December 31, 1960.

"Art," *Nation,* January 21, 1961 [Morandi, Vasilieff].

"Art," *Nation,* February 11, 1961 [Georges; the nature of artistic tradition].

"Art," *Nation,* February 25, 1961 [Edwin Dickinson, Rothko, Richenburg].

Book review of *Classical Greece. The Elgin Marbles of the Parthenon* by Nicholas Yalouris, *Greek Sculpture. A Critical Review* by Rhys Carpenter, *Ancient Egypt. The New Kingdom and the Amarna Period,* by Christine Desroches Noblecourt, *Nation,* March 11, 1961.

"Art," *Nation,* March 18, 1961 [art and communication; Tworkov, Katz].

"Art," *Nation,* April 8, 1961 [Italian drawings; French art from 1600 - 1750].

"Art," *Nation,* April 29, 1961 [Motherwell, Elaine de Kooning].

"Art," *Nation,* May 20, 1961 [Mitchell, di Suvero, Bladen contrasted with realists at the National Arts Club].

"Art," *Nation,* June 10, 1961 [American painting 1865 - 1905].

"Poets and Painters in Collaboration," *Evergreen Review,* September - October 1961.

"Class Content in American Abstract Painting," *Art News,* April 1962.

"Recent Painting USA: The Figure," *Art in America* 50, no. 1, 1962.

"The Education of Jasper Johns," *Art News,* February 1964.

"Against Idealism," *Art and Literature,* no. 2, Summer 1964.

Letter to the editor:"The Plane in Maine," *Arts,* October 1964.

"Art and Knowledge," *Art News,* February 1966.

"Joseph Cornell," *Art and Literature,* no. 8, Spring 1966.

"The Prendergast Anomaly, *Art News,* November 1966.

"Fairfield Porter: People are afraid they may overlook something," *Art in America,* January 1967 [response to a questionnaire: "Is there a sensibility of the sixties?"].

Art Now: New York (University Galleries Inc., N.Y.) 1, no. 6, June 1969 [statement on his painting *Cooper Square*].

"Ban the Megamuseum," *Art News,* January 1970 [contribution to a symposium: "The Metropolitan Museum, 1870 - 1970 - 2001"].

"Speaking Likeness," *Art News Annual* 36, 1970.

"Robert White," Graham Galleries, New York, 1970 [catalogue introduction].

Statement on his painting in Alan Gussow, *A Sense of Place: The Artist and the American Land,* San Francisco/New York: Friends of the Earth/Seabury Press, 1971.

"Nuclear Power Plants: The Principal Objection," *New York Times,* January 31, 1974 [letter to the editor].

"Albert York," Davis and Long Galleries, New York, 1974.

Recent Works by Fairfield Porter, Hirschl & Adler Galleries, New York, 1974 [catalogue statement].

"Two Books about de Kooning," *Print Collector's Newsletter,* January - February 1975.

Fairfield Porter Retrospective Exhibition, Heckscher Museum, Huntington, N.Y., 1975 [catalogue statement].

Public Addresses

When he spoke in public, Porter often read from a prepared text. Manuscripts exist of the following addresses:

"The Arts Today: The Reflection of a Sick Society?" Symposium at the University of Alabama, 1967.

Address to the Amherst Faculty Club, Amherst College, December 2, 1969.

"Art Should be Independent of Science," Symposium at Amherst College, 1970.

Address at a memorial tribute to Joseph Cornell, Metropolitan Museum, January 13, 1973.

Introduction to a poetry reading by John Ashbery, Guggenheim Museum, New York, January 30, 1973.

"Technology and Artistic Perception," Yale School of Art and Architecture, April 8, 1975 [published in *Fairfield Porter: Art in its Own Terms*].

Poems

"The Pyromanica," "The Island in the Evening," "Great Spruce Head Island," in *Poetry* (Chicago), vol. 85, p. 325, March 1955.

"Sestina" in *Semi-Colon* (New York), vol. 2, no. 3 [1955].

"In One Small Moment" in *i.e. Cambridge Review* (Cambridge, Mass.), vol. 1, no. 6, December 1956.

"The Mountain," "To Laurence," "At the End of Summer," "When the Morning Train" in *Locus Solus* (Lans-en-Vercours, France) 1, Winter 1961.

"The Wave and the Leaf" in *49 South* (Southampton, New York), single issue magazine [1972].

"Tomb" (translation of Mallarmé's "Tombeau") in *World* (New York), no. 27, April 4, 1973.

II. Writings about Fairfield Porter

A selected general list, with special emphasis on Porter's print-making activities, is contained in Joan Ludman's *Fairfield Porter. A Catalogue Raisonné of his Prints* (Westbury, N.Y., 1981). This is indispensable as a source of references of all kinds dating from the mid-sixties on.

Reviews, Essays, Interviews

*indicates a discussion of several artists (of paintings unless otherwise noted.)

*Theodore Cohen. "Paintings," *New York Times*, May 14, 1933 (column mentions an early two-man exhibition including Porter.)

Stuart Preston, "Intimist," *New York Times*, October 12, 1952.

Lawrence Campbell, "Reviews and Previews," *Art News*, October 1952.

James Fitzsimmons, "Fifty-Seventh Street in Review," *Art Digest*, November 1, 1952.

Howard De Vree, "About Art and Artists," *New York Times*, April 15, 1954.

Frank O'Hara, "Reviews and Previews," *Art News*, April 1954.

Dore Ashton, "Fortnight in Review," *Art Digest*, May 1, 1954.

Frank O'Hara, "Porter Paints a Picture," *Art News*, January 1955.

Stuart Preston, "Fairfield Porter's Tranquil Realism," *New York Times*, February 8, 1955.

Robert Rosenblum, "Fortnight in Review," *Art Digest*, February 15, 1955.

Lawrence Campbell, "Reviews and Previews," *Art News*, March 1955.

Stuart Preston, "From Tradition to Abstraction," *New York Times*, April 1, 1956.

James R. Mellow, "In the Galleries," *Arts*, April 1956.

Park Tyler, "Selecting From the Flow of Spring Shows," *Art News*, April 1956.

*Thomas B. Hess, "Some Recent Directions," *Art News Annual* 25, 1956.

Maurice Grosser, "Art," *Nation*, May 10, 1958.

James Schuyler, "Reviews and Previews," *Art News*, May 1958.

R. Warren Dash, "In the Galleries," *Arts*, June 1958.

R. D. [Robert Dash], "Reviews and Previews," *Art News*, March 1959.

Sidney Tillim, "In the Galleries," *Arts*, March 1959.

Lawrence Campbell, "Reviews and Previews," *Art News*, November 1960.

Sidney Tillim, "Month in Review," *Arts*, December 1960.

James Schuyler, "Exhibitions for 1961-62," *Art News*, January 1962.

Sidney Tillim, "In the Galleries," *Arts*, February 1962.

*Valerie Petersen, "U.S. Figure Painting: Continuity and Cliché," *Art News*, Summer 1962.

[unsigned], "Point of Departure," *Newsweek*, February 11, 1963.

Sidney Tillim, "In the Galleries," *Arts*, March 1963.

Lawrence Campbell, "Reviews and Previews," *Art News*, March 1963.

Hilton Kramer, "The Duality of Fairfield Porter," in "New York, Season's Gleanings," *Art In America*, June 1963.

Brian O'Doherty, "By Fairfield Porter: His School of Paris Works, Which Bring the Outdoors In, Shown at de Nagy's," *New York Times*, March 24, 1964.

Michael Benedikt, "Fairfield Porter: Minimum of Melodrama," *Art News*, March 1964.

Brie Taylor, "Towards a Plastic Revolution," *Art News*, March 1964 (discusses Porter's use of synthetic painting mediums).

Jerrold Lanes, "Fairfield Porter's Recent Work," *Arts*, April 1964.

*[unsigned], "They Paint: You Recognize," *Time*, April 3, 1964.

[unsigned], *New York Herald Tribune*, February 20, 1965.

James Schuyler, "Reviews and Previews," *Art News*, February 1965.

*Vivien Raynor, "In the Galleries," *Arts*, April 1965.

Hilton Kramer, "Fairfield Porter: Against the Historical Grain," *New York Times*, February 20, 1966.

Sidney Zimmerman, "In the Galleries," *Arts*, April 1966.

Anne Tabachnick, "Reviews and Previews," *Art News*, February 1967.

*James Schuyler, "Immediacy is the Message," *Art News*, March 1967.

C.F. I. [Colta Feller Ives], "In the Galleries," *Arts*, April 1967.

Hilton Kramer, *New York Times*, December 2, 1967 [exhibition of drawings].

*Ralph Pomeroy, "Reviews and Previews," *Art News*, February 1968.

*Norman Geske, *Venice 34: The Figurative Tradition in Recent American Art*, National Collection of Fine Arts/Smithsonian, Washington, D.C., 1968.

*Grace Glueck, "Nature with Manners," *New York Times*, January 19, 1969.

Hilton Kramer, "An Art of Conservation," *New York Times,* February 9, 1969.

Michael Benedikt, "Reviews and Previews," *Art News,* February 1969.

C.N. [Cindy Nemser], "In the Galleries," *Arts,* February 1969.

James Carpenter, *Fairfield Porter Paintings - Eliot Porter Photographs,* Colby College Art Museum, Waterville, Maine, 1969 (exhibition catalogue, with essay).

James R. Mellow, "New York Letter," *Art International,* March 1969.

Lawrence Campbell, "Reviews and Previews," *Art News,* April 1970.

*Janet Hobhouse, "In the Galleries," *Arts,* April 1970.

Hilton Kramer, *New York Times,* April 18, 1970.

Carter Ratcliff, "New York," *Art International,* Summer 1970.

Hilton Kramer, *New York Times,* January 9, 1971.

John Ashbery, "Reviews and Previews," *Art News,* January 1971.

Gerrit Henry, "New York Letter," *Art International,* February 1971.

*H. Gordon, "A Standard in Painting," *Arts,* March 1971.

Edward B. Henning, "South of His House, North of His House: Nyack, A Painting by Fairfield Porter," *Cleveland Museum Bulletin,* March 1971.

*Riva Castleman, "Ten Lithographs by Ten Artists," New York, *Bank Street Atelier,* 1971 (portfolio introduction).

Peter Schjeldahl, "Recent Work by Fairfield Porter," *Hirschl & Adler Galleries, Inc.,* New York, 1972 (catalogue essay).

James R. Mellow, *New York Times,* April 15, 1972.

Marianne Hancock, "In the Galleries," *Arts,* May 1972.

Alvin Smith, *Art International,* Summer 1972.

Paul Cummings, "Fairfield Porter," Archives of American Art *Journal* 12, no. 2, 1972.

*David Shapiro, ed., *Social Realism: Art as a Weapon,* New York, 1973.

Malcolm Preston, "Porter Without Flair," *Newsday,* September 11, 1973.

*Judith Goldman, "Exploring the Possibilities of the Print Medium," *Art News,* September 1973.

Howard Schneider, "Me, by Fairfield Porter — and Vice Versa," *Newsday,* February 17, 1974.

Hilton Kramer, *New York Times,* March 9, 1974.

Carter Ratcliff, "Reviews and Previews," *Art News,* April 1974.

Phyllis Derfner, "New York Letter," *Art International,* May 1974.

Lawrence Campbell, "Reviews and Previews," *Art News,* May 1974.

Judith Tannenbaum, "Arts Reviews," *Arts,* May 1974.

Harriet Shorr, *Art in America,* May 1974.

Eva Ingersoll Gatling, *Fairfield Porter Retrospective Exhibition* Heckscher Museum, Huntington, N.Y., 1974 (catalogue introduction).

David Shirey, "Porter's Works on Display," *New York Times,* December 22, 1974.

*Rackstraw Downes, "What the Sixties Meant To Me," *Art Journal,* Winter 1974/75.

Grace Glueck, "Fairfield Porter, 68, A Realist in an Age of Abstract Art, Dies," *New York Times,* September 20, 1975.

Thomas B. Hess, "Fairfield Porter," *New York,* December 22, 1975.

Kenneth Wahl, *57th Street Review,* December 1975 (watercolors).

David Shapiro, "Paying Attention: Fairfield Porter's Watercolors," *57th Street Review* (supplement), December 1975.

John Bernard Myers, "Fairfield Porter [1907-1975]," *Parenthèse* 3, 1975.

John Ashbery, "Fairfield Porter, 1907-75," *Art in America,* January- February 1976.

Allan Ellenzweig, *Arts,* February 1976 (watercolors).

Patricia Mainardi, "Fairfield Porter's Contribution to Modernism," *Art News,* February 1976.

Carter Ratcliff, "New York Letter," *Art International,* February- March 1976 (watercolors).

Benjamin De Mott, "Culture Watch," *Atlantic,* April 1976.

Prescott Schutz, *Fairfield Porter - His Last Works 1974-1975,* Hirschl & Adler Galleries, New York, 1976 (catalogue introduction).

Hilton Kramer, "Chase, Porter and History," *New York Times,* May 14, 1976.

Louis Finkelstein, "The Naturalness of Fairfield Porter," *Arts Magazine,* May 1976.

*John Russell, "Trapping the Look of New York," *New York Times,* April 24, 1977.

Helen A. Harrison, *Fairfield Porter's Maine,* Parrish Art Museum, Southampton, N.Y., 1977 (catalogue introduction).

Claire Nicolas White, *Fairfield Porter,* Harbor Gallery, Cold Spring Harbor, N.Y. 1977 (catalogue introduction).

Malcolm Preston, "Porter in Maine," *Newsday,* August 22, 1977.

Gerrit Henry, *Art News,* November 1977 (drawing exhibition).

Norman Turner, *Arts,* December 1977 (drawing exhibition).

*Jed Perl, "Life of the Object: Still Life Painting Today," *Arts,* December 1977.

*Irving Sandler, *The New York School: Painters and Sculptors of the Fifties,* New York, 1978.

E.A. Beem, "People and Things Connected — Fairfield Porter, Creator and Critic," *Portland Independent* (Portland, Maine), July 27, 1979.

Rackstraw Downes, *Fairfield Porter*, Barridoff Galleries, Portland, Maine, 1979 (catalogue essay).

Prescott Schutz, *Fairfield Porter — Figurative Painting*, Hirschl & Adler Galleries, New York, 1979 (catalogue introduction).

Hilton Kramer, "Porter — A Virtuoso Colorist," *New York Times,* November 25, 1979.

Paul Richard, "Strokes of City Light: Fairfield Porter's Window on New York," *Washington Post,* December 15, 1979.

Pearl Oxorn, "Fairfield Porter," *Washington Star,* December 16, 1979.

Susan Grace Galassi, *Arts,* January 1980.

Robert Berlind, *Art in America,* February 1980.

Jed Perl, *Arts,* February 1980.

Philip Ferrato, *The Porter Family,* Parrish Art Museum, Southampton, N.Y., 1980 (catalogue essay).

*John Arthur, *Realist Drawings and Watercolors: Contemporary American Works on Paper,* Boston, 1980.

*Hilton Kramer, "Portraiture, the Living Art," *Harper's Bazaar,* March 1981.

*Frank H. Goodyear, Jr., *Contemporary American Realism Since 1960,* Boston, 1981.

Joan Ludman, *Fairfield Porter. A Catalogue Raisonné of His Prints,* with appreciations by David Shapiro and Brooke Alexander and an interview with Jane Freilicher by Fred Dietzel. Westbury, N.Y., 1981.

Reviews of Porter's writings
Reviews of Thomas Eakins
Aline B. Saarinen, *New York Times Book Review,* September 27, 1959.

George Heard Hamilton, "U.S. Art Begins to Get a Literature," *Art News,* October 1959.

Hilton Kramer, "Critics of American Paintings," *Arts,* October 1959.

Lincoln Kirstein, *Nation,* December 12, 1959.

Jed Perl, "Porter's Portrait of Thomas Eakins," *Arts,* May 1979.

Reviews of Art in Its Own Terms. Selected Criticism 1935-1975
John Bernard Myers, "Painting on a Painter's Terms," *Art World,* May 18/June 18, 1979.

Hilton Kramer, "Unexpected Linkages," *New York Times Book Review,* June 3, 1979.

William Zimmer, "Art In Its Own Terms," *Soho Weekly News,* June 21, 1979.

"Briefly Noted," *New Yorker,* August 20, 1979.

Lawrence Alloway, *Nation,* August 25, 1979.

Robert Berlind, *Art in America,* September 1979.

Susan Wheeler, "Fairfield Porter," *New Boston Review,* September - October 1979.

Miles Edward Friend, *Journal of Aesthetic Education* (University of Illinois), July 1980.

Editorial: "The Painter as Critic," *Apollo,* August 1981.

* *

Checklist

*1
Seated Boy, ca. 1938
Oil on board, 18⅛ x 14 in.
The Parrish Art Museum,
Southampton, New York

2
First Avenue, ca. 1945
Oil on canvas, 30 x 25 in.
The Parrish Art Museum,
Southampton, New York

*3
Self-Portrait, 1948
Oil on canvas, 30 x 24 in.
Hirschl & Adler Modern, New York

4
Bedroom, ca. 1948
Oil on masonite, 16 x 11⅞ in.
The Parrish Art Museum,
Southampton, New York

*5
Interior, 1951
Oil on panel, 15½ x 11½ in.
Collection of Mr. and Mrs. David R. Pokross

6
Larry Rivers, 1951
Oil on canvas, 40 x 30 in.
Collection of Katherine Porter, Belfast, Maine

7
Studio Interior, 1951
Oil on canvas, 35¾ x 42 in.
Mickelson Gallery, Washington, D.C.

*8
Backyard, Southampton, 1953
Oil on canvas, 42 x 43¾ in.
The Parrish Art Museum,
Southampton, New York

*9
Frank Wallace, 1953
Oil on canvas, 40 x 30 in.
The Parrish Art Museum,
Southampton, New York

10
Katie in an Armchair, 1954
Oil on canvas, 65½ x 46 in.
Collection of Katharine Porter, Albuquerque,
New Mexico

*11
Lunch under the Elm Tree, 1954
Oil on canvas, 55⅛ x 48⅛ in.
The Parrish Art Museum,
Southampton, New York

12
The Harbor through the Trees, 1954
Oil on canvas, 25½ x 25½ in.
Collection of the Chase Manhattan Bank,
New York

13
Armchair on Porch, 1955
Oil on canvas, 37½ x 45 in.
Collection of Tibor de Nagy. Courtesy of Tibor
de Nagy Gallery, New York

14
Katie and Anne, 1955
Oil on canvas, 80⅛ x 62⅛ in.
Hirshhorn Museum and Sculpture Garden,
Smithsonian Institution, Washington, D.C.

15
Jerry, 1955 (repainted 1975)
Oil on canvas, 62 x 37 in.
Collection of Ashby McCulloch Sutherland

*16
Elaine de Kooning, 1957
Oil on canvas, 62 x 41 in.
The Metropolitan Museum of Art, New York.
Gift of Mrs. Fairfield Porter

*17
Jerry on a Stool, 1957
Oil on canvas, 38 x 20 in.
Collection of Arthur M. Bullowa

18
Katie and Dorothy E., 1957
Oil on canvas, 16 x 20¾ in.
Private Collection

19
Robert Dash, 1957
Oil on canvas, 36 x 36 in.
Collection of Mr. and Mrs. Emanuel Dash

20
Jimmy and John, 1957-1958
Oil on canvas, 36¼ x 45½ in.
Collection of Dr. and Mrs. Sidney Goldman

21
Lizzie at the Table, 1958
Oil on canvas, 37 x 45 in.
Collection of Arthur M. Bullowa

*22
Tibor de Nagy, 1958
Oil on canvas, 40 x 30 in.
Collection of Tibor de Nagy. Courtesy of Tibor
de Nagy Gallery, New York

*23
Still Life with Flowers, 1958
Oil on canvas, 24½ x 30 in.
Collection of Mr. and Mrs. E. Powis Jones

*24
Plane Tree in October, 1958
Oil on canvas, 45 x 42 in.
Hirschl & Adler Modern, New York

25
Trumpet Vines, 1958
Oil on canvas, 28 x 20 in.
Collection of Arthur M. Bullowa

*26
AKJ, 1959
Oil on canvas, 36 x 48 in.
Collection of Mr. and Mrs. E. Powis Jones

27
Schwenk, 1959
Oil on canvas, 22⅝ x 31 in.
The Museum of Modern Art, New York. Gift
of Arthur M. Bullowa

*28
Still Life, 1959
Oil on canvas, 32 x 22 in.
Hirschl & Adler Modern, New York

*Exhibited in Boston only

***29**
The Door, 1959
Oil on wood, 9 x 12¾ in.
Collection of Mr. and Mrs. M.H. Blinken

***30**
University Place, 1960
Oil on canvas, 30 x 24 in.
Private Collection

***31**
View from Studio Window, 1960
Oil on canvas, 36 x 36 in.
Susanne Hilberry Gallery, Detroit

***32**
Bob Carey and Andy Warhol, 1960
Oil on canvas, 40 x 40 in.
Whitney Museum of American Art, New
York. Gift of Andy Warhol

***33**
Johnny, 1960
Oil on canvas, 28½ x 24½ in.
Collection of Mrs. Fairfield Porter

34
Calm Morning, 1961
Oil on canvas, 36 x 36 in.
Collection of Arthur M. Bullowa

***35**
Elizabeth in Red Chair, 1961
Oil on canvas, 44¾ x 39¾ in.
The Heckscher Museum, Huntington, New
York. Gift of the Family of Fairfield Porter

***36**
Southeast from Bear Island, 1962
Oil on canvas, 39 x 46½ in.
Private Collection

37
Summer Studio, 1962
Oil on canvas, 54½ x 37 in.
Collection of Mr. and Mrs. Robert Graham, Sr.

***38**
The Garden Road, 1962
Oil on canvas, 62 x 48 in.
Whitney Museum of American Art, New
York. Gift of the Greylock Foundation

39
A Short Walk, 1963
Oil on canvas, 62 x 48 in.
Private Collection

40
Interior with a Doll's House, 1963
Oil on canvas, 36 x 36 in.
Collection of Ashby McCulloch Sutherland

41
Elizabeth Thinking, 1963
Oil on canvas, 28 x 30 in.
Collection of Olga Bellin Roebling

42
October Interior, 1963
Oil on canvas, 56 x 72 in.
Collection of Olga Bellin Roebling

43
Portrait of Don Schrader, 1963
Oil on canvas, 30 x 28 in.
Collection of Arthur M. Bullowa

44
July Interior, 1964
Oil on canvas, 56⅛ x 72 in.
Hirshhorn Museum and Sculpture Garden,
Smithsonian Institution, Washington, D.C.

***45**
Still Life with Standing Figure, 1964
Oil on canvas, 45 x 45 in.
Collection of Mr. and Mrs. Theodore Norman

***46**
Child by Window, 1965
Oil on cigar box, 8¼ x 5¾ in.
Collection of Mr. and Mrs. Theodore Norman

47
Elizabeth, 1965
Oil on canvas, 48 x 24 in.
Collection of Mr. and Mrs. Alan Fink

48
Flowers by the Sea, 1965
Oil on composition board, 20 x 19½ in.
The Museum of Modern Art, New York.
Larry Aldrich Foundation

***49**
Park Avenue South, 1965
Oil on masonite, 9 x 7½ in.
Collection of Mr. and Mrs. Theodore Norman

***50**
The Schooner II, 1964
Oil on canvas, 37 x 54½ in.
Private Collection

51
Dinner Table, 1965
Oil on canvas, 34 x 48 in.
Collection of Olga Bellin Roebling

***52**
Anemone and Daffodil, 1965
Oil on board, 20 x 16⅜ in.
Collection of Olga Bellin Roebling

***53**
Watermill, 1965
Oil on masonite, 9 x 8 in.
Collection of Olga Bellin Roebling

***54**
Red Tulips, 1965
Oil on masonite, 14¼ x 15⅞ in.
Collection of Mr. and Mrs. Austin List

***55**
Self-Portrait, 1965
Oil on canvas, 17 x 16½ in.
Private Collection

***56**
Still Life, ca. 1965
Oil on canvas, 19½ x 24½ in.
Collection of John Gruen and Jane Wilson

57
Early Morning, 1966
Oil on canvas, 32 x 28 in.
Collection of Marianne de Nagy
(Buchenhorner). Courtesy of Tibor de Nagy
Gallery, New York

58
Iced Coffee, 1966
Oil on canvas, 79⅛ x 79⅛ in.
Private Collection

***59**
Living Room with Mirror, 1966
Oil on masonite, 24 x 24 in.
Weatherspoon Art Gallery, Greensboro,
North Carolina

***60**
Red House on Cobb Road, 1966
Oil on canvas, 10 x 14 in.
Collection of A. Aladar Marberger

***61**
The Mirror, 1966
Oil on canvas, 72 x 60 in.
Collection of Olga Bellin Roebling

***62**
Rosa Rugosa, 1966
Oil on masonite, 18 x 14 in.
Collection of Ashby McCulloch Sutherland

63
Nyack, 1966-1967
Oil on canvas, 82 x 110 in.
Contemporary Collection of the Cleveland
Museum of Art

64
Apples and Roses, 1967
Oil on canvas, 22 x 18 in.
Collection of Mrs. Robert T. Drake

65
Jane and Elizabeth, 1967
Oil on canvas, 55⅛ x 48⅛ in.
The Parrish Art Museum,
Southampton, New York

***66**
Sayer House, 1967
Oil on canvas, 14 x 19 in.
Collection of Rosanne Diamond Zinn

67
Spring Landscape, 1967
Oil on canvas, 18 x 19 in.
Collection of Dr. and Mrs. Ronald Abrahams

***68**
Still Life with Red Tablecloth, 1968
Oil on panel, 18 x 20 in.
Private Collection

69
Columbus Day, 1968
Oil on canvas, 80 x 80 in.
Collection of Marianne de Nagy
(Buchenhorner). Courtesy of Tibor de Nagy
Gallery, New York

70
Cooper Square, 1968
Oil on masonite, 18½ x 22 in.
Hirschl & Adler Modern, New York

71
Inez MacWhinnie, 1968
Oil on masonite, 20 x 18 in.
Collection of John MacWhinnie

***72**
Self-Portrait, 1968
Oil on canvas, 59 x 45½ in.
The Dayton Art Institute. Museum Purchase
with funds provided by the National
Endowment for the Arts and various other
sources

73
Self-Portrait in the Studio, 1968
Oil on panel, 22 x 16 in.
Private Collection

74
Still Life with White Boats, 1968
Oil on canvas, 20 x 20 in.
Collection of Tibor de Nagy. Courtesy of Tibor
de Nagy Gallery, New York

75
The Windows, 1968
Oil on board, 20 x 18 in.
Collection of Arthur M. Bullowa

***76**
Young Man, 1968
Oil on masonite, 20 x 18 in.
Hirschl & Adler Modern, New York

77
Still Life with Cherries and Peaches, 1968
Oil on panel, 18 x 22 in.
Collection of Jane Freilicher and Joe Hazan

78
Boathouses and Lobster Pots, 1968-1972
Oil on canvas, 48 x 60 in.
Mead Art Museum, Amherst, Massachusetts

79
Amherst Parking Lot No. 1, 1969
Oil on canvas, 62¼ x 46 in.
Hirschl & Adler Modern, New York

80
Interior with a Dress Pattern, 1969
Oil on canvas, 62 x 46 in.
Collection of Mr. and Mrs. Austin List

81
Island Farmhouse, 1969
Oil on canvas, 79⅞ x 79½ in.
Private Collection, Cleveland

82
Ice Storm, 1969
Oil on canvas, 26 x 28 in.
Collection of Mr. and Mrs. Thomas F. O'Toole

***83**
The Fire, ca. 1969
Oil on panel, 18 x 22 in.
Collection of Elizabeth Porter

84
Lizzie and Bruno, 1970
Oil on canvas, 59¾ x 24½ in.
Collection of Dr. and Mrs. Joseph Del Gaudio

85
Red and Brown Interior, 1970
Oil on board, 16 x 14 in.
Collection of Xavier Fourcade, New York

86
View of the Barred Islands, 1970
Oil on canvas, 40 x 50 in.
On extended loan to the Rose Art Museum,
Brandeis University, from The Herbert W.
Plimpton Foundation

87
Aline by the Screen Door, 1971
Oil on canvas, 54⅞ x 48 in.
Collection of Stephen S. Alpert, Wayland,
Massachusetts

***88**
Mackerel Sky, 1971
Oil on masonite, 18 x 14 in.
Collection of Mr. and Mrs. Martin E. Segal

89
Under the Elms, 1971-1972
Oil on canvas, 62⅜ x 46 in.
The Pennsylvania Academy of the Fine Arts,
Philadelphia. Gift of Mrs. Fairfield Porter

*90
Sun on the Ocean, 1972
Oil on canvas, 32 x 35 in.
Private Collection

91
House in a Thicket, 1972
Oil on canvas, 24 x 30 in.
Private Collection

92
Landscape with Two Parked Cars, 1972
Oil on canvas, 30⅛ x 25⅛ in.
Hirschl & Adler Modern, New York

*93
Self-Portrait, 1972
Oil on board, 14¼ x 10⅞ in.
The Parrish Art Museum,
Southampton, New York

94
Single Peonies, 1972
Oil on masonite, 14⅛ x 11¹³⁄₁₆ in.
Hirschl & Adler Modern, New York

*95
The Ocean, 1972
Oil on canvas, 40 x 40 in.
Collection of Mr. and Mrs. A.J. Lambert

96
The Screen Porch, 1972
Oil on canvas, 79½ x 79½ in.
Whitney Museum of American Art, New
York. Lawrence H. Bloedel Bequest

97
The Sweater, 1972
Oil on canvas, 22¾ x 31¼ in.
Collection of Mr. and Mrs. Austin List

98
The Tennis Game, 1972
Oil on canvas, 72½ x 62¼ in.
Lauren Rogers Library and Museum of Art,
Laurel, Mississippi

99
White Rose and Peaches, 1972
Oil on masonite, 10⅞ x 14³⁄₁₆ in.
Collection of Mr. and Mrs. Austin List

*100
Boat Off Shore, 1972
Oil on board, 16 x 14 in.
Collection of Gary and Irene Edwards

101
Door to the Woods, ca. 1972
Oil on canvas, 60 x 46½ in.
Private Collection, New York

102
View From a High Ledge, No. 2, 1972-1975
Oil on canvas, 44 x 32 in.
Private Collection, Louisville, Kentucky

103
The Mail Boat, 1973
Oil on canvas, 47 x 39¼ in.
Collection of A. Wade Perry

104
Sun Rising out of the Mist, 1973
Oil on canvas, 55 x 37 in.
Collection of Mr. and Mrs. John W. Payson

105
A Sudden Change of Wind, 1973
Oil on canvas, 24 x 30 in.
Private Collection

106
Logs and Rocking Chair, 1973
Oil on masonite, 22 x 18 in.
Collection of Joan and Harold Ludman

107
Nancy Porter Straus, 1973
Oil on canvas, 68 x 80 in.
Museum of Fine Arts, Boston. Anonymous
Gift

108
Fish Hawk Point, 1973
Oil on board, 22 x 18 in.
Collection of Elizabeth Porter

109
Blue Sunrise, 1974
Oil on board, 21½ x 17½ in.
Collection of Mr. and Mrs. Daniel Gordon

*110
Cliffs of Isle au Haut, 1974
Oil on canvas, 72 x 62 in.
Collection of Graham Gund

111
Katie, 1974
Oil on board, 22 x 18 in.
Private Collection

112
Monument Mountain, 1974
Oil on panel, 18 x 22 in.
Private Collection, Stockbridge

113
Anne in Doorway, 1974
Oil on canvas, 47 x 37 in.
The Heckscher Museum, Huntington, New
York. Gift of Mrs. Fairfield Porter

*114
Waves Going By, 1974
Oil on board, 18 x 14 in.
Collection of Katharine Porter and Daniel
Fishbein

115
Richard Freeman, 1974
Oil on board, 22 x 18 in.
Hirschl & Adler Modern, New York

116
The Harbor — Great Spruce Head, 1974
Oil on canvas, 20 x 36 in.
Collection of Linda and Ross Rapaport

117
Violet Sky, 1974
Oil on board, 22 x 18 in.
Private Collection

*118
Bear Island — June, 1974
Oil on board, 18 x 22 in.
Collection of Mr. and Mrs. Martin E. Segal

119
Broadway South of Union Square, 1975
Oil on canvas, 38 x 30 in.
Collection of Mr. and Mrs. Austin List

120
Persian Rose Bush, 1975
Oil on board, 30 x 22 in.
Collection of Mr. and Mrs. Austin List

121
Backyards, 1975
Oil on board, 30 x 22 in.
Collection of Mrs. Fairfield Porter

***122**
Fourth of July Sunrise, 1975
Oil on board, 18 x 22 in.
Private Collection

***123**
Plane Tree and House Next Door, 1975
Oil on board, 30 x 22 in.
Private Collection, Boston

124
The Privet Hedge, 1975
Oil on masonite, 18 x 22 in.
Collection of Mr. and Mrs. Alan Fink

125
*Near Union Square — Looking up Park
Avenue,* 1975
Oil on canvas, 61¼ x 72 in.
The Metropolitan Museum of Art, New York.
Gift of Mrs. Fairfield Porter

***126**
Jerry in a Wicker Chair, undated
Oil on masonite, 21¾ x 16¾ in.
The Parrish Art Museum, Southampton,
New York

***127**
Main Street, undated
Oil on canvas, 34½ x 29½ in.
Collection of the Chase Manhattan Bank,
New York

***128**
Cambridge Rooftops, 1927
Watercolor on cardboard, 13⅞ x 20 in.
The Parrish Art Museum, Southampton,
New York

***129**
Jane Freilicher, ca. 1955
Pastel on paper, 16¾ x 9 in.
Hirschl & Adler Modern, New York

***130**
Three Boats, 1961
Pencil on paper, 10 x 13 in.
Collection of Mr. and Mrs. Austin List

***131**
Untitled, ca. 1961
Watercolor on paper, 10 x 14 in.
Collection of Mrs. William Overman

***132**
Untitled, ca. 1961
Watercolor on paper, 10 x 14 in.
Collection of Mrs. William Overman

***133**
Cooper Square, 1968
Ink on paper, 11 x 13¾ in.
Hirschl & Adler Modern, New York

***134**
The Table, 1970
Watercolor on paper, 30 x 24 in.
Collection of Elizabeth Feld

***135**
Union Square, 1973
Oil on paper, 13¾ x 17 in.
Collection of Mr. and Mrs. Gary Edwards

***136**
Morning from the Porch, 1974
Watercolor on paper, 22½ x 29⅞ in.
The Heckscher Museum, Huntington, New
York. Museum Purchase

***137**
Sketch for "The Cliffs of Isle au Haut," 1974
Watercolor on paper, 26 x 22 in.
Private Collection

***138**
Skokie Beach, 1974
Watercolor on paper, 12 x 16 in.
Collection of Arthur and Carol Goldberg

***139**
The Harbor — Great Spruce Head Island, ca.
1974
Ink on paper, 14 x 11 in.
Private Collection

***140**
Still Life, 1975
Watercolor on paper, 22½ x 30½ in.
Collection of Barbara Ingber. Courtesy of
Ingber Gallery, New York

***141**
Garden on Great Spruce Head, 1975
Watercolor on paper, 22½ x 30½ in.
Heublein, Inc., Corporate Art Collection

***142**
View of Islands, Maine, 1975
Watercolor on paper, 16 x 12 in.
Collection of Arthur and Carol Goldberg

***143**
Western View, No. 2, 1975
Watercolor on paper, 16 x 12 in.
Private Collection, Boston

***144**
Breakfast Table, undated
Watercolor and pastel on paper, 22 x 30 in.
Private Collection, Boston